PORTRAITS

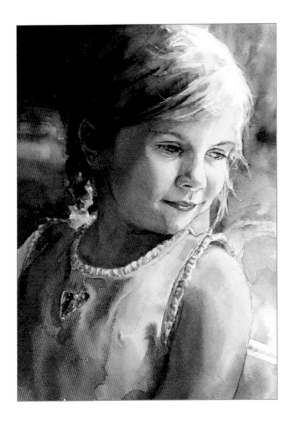

By Peggi Habets

www.walterfoster.com

Walter Foster Publishing, Inc.
3 Wrigley, Suite A
Irvine, CA 92618
USA
www.walterfoster.com

Author: Peggi Habets
Project Editor: Sarah Womack
Associate Publisher: Rebecca J. Razo
Art Director: Shelley Baugh
Senior Editor: Amanda Weston
Associate Editor: Stephanie Meissner
Copyeditor: Elizabeth T. Gilbert
Production Artists: Debbie Aiken, Amanda Tannen
Production Manager: Nicole Szawlowski
Production Coordinator: Lawrence Marquez
Administrative Assistant: Kate Davidson

10 9 8 7 6 5 4 3 2

CONTENTS

INTRODUCTION

When I tell people that I paint portraits in watercolor, the most common reply is, "I wouldn't try that; watercolor is too difficult." My answer to them is, "Watercolor is as hard or as easy as you make it." Every medium has its strengths and drawbacks. Watercolor, for example, is fluid and spontaneous. If your goal is to make a watercolor that looks like other traditional portrait media (oils or pastels, for example), your attempts will lead to frustration. However, if you allow the active and sometimes unpredictable nature of watercolor to work its magic, it can lead to some surprising and interesting effects.

Along with showing you how to use these effects to your advantage, this book will arm you with the tools you need to create a well designed, expressive watercolor portrait. I hope this book will give you the confidence to try something new and encourage you to continue practicing long after you have finished these nine projects.

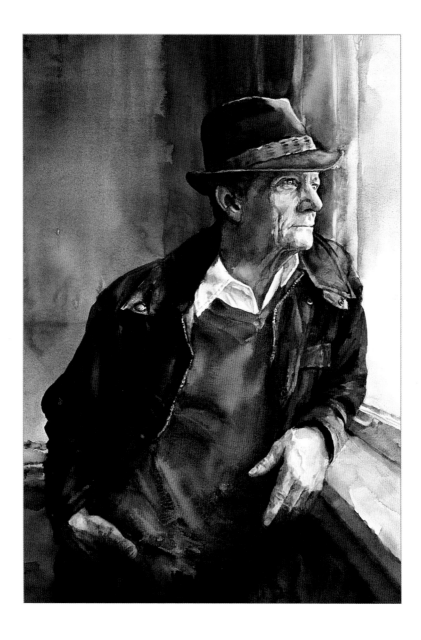

TOOLS & MATERIALS

I've spent several years researching and experimenting with various watercolor paints, papers, and brushes. On the following pages, I will show you the tools and materials I've had success using. You may find that some work well for you and others do not. In the end, an artist's choice of tools is as individual as his or her unique painting style.

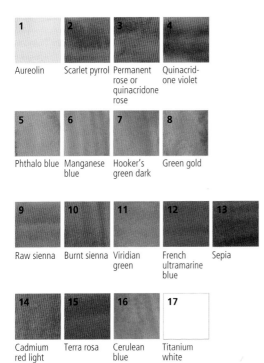

1 Aureolin
2 Scarlet pyrrol
3 Permanent rose or quinacridone rose
4 Quinacridone violet
5 Phthalo blue
6 Manganese blue
7 Hooker's green dark
8 Green gold
9 Raw sienna
10 Burnt sienna
11 Viridian green
12 French ultramarine blue
13 Sepia
14 Cadmium red light
15 Terra rosa
16 Cerulean blue
17 Titanium white

Paint

I won't recommend a specific brand of paint, as there are more than enough quality brands to choose from. I will stress, however, that a professional grade tube is the most important criteria for fresh, vibrant color. Tube paints are wet and soft. Pan paints are hard, dry cakes of paint, which you need to activate with water. Your colors will be more vivid and saturated if you stick with tubes.

I use a combination of transparent, semi-transparent, and opaque paints. Transparent colors allow the white of the paper or other colors underneath to show through. This enables you to build layers of color. Opaque paints are very dense. When they are full strength, they cover up some or all of the color underneath. Semi-transparent colors are denser than transparent but not fully opaque.

I use opaque paints early on in the painting and glaze over them with transparent color, or I add more water to the opaque paints and use them for special effects over other colors. When used too heavily, opaques can result in dull, lifeless, or muddy colors.

I use a limited palette of the 17 colors shown here. Numbers one through eight are transparent colors, nine through 13 are semi-transparent, and 14 through 17 are opaque.

Palette

I use a plastic palette with a lid to keep the paint from drying out when I'm not working. My palette contains 25 open-ended wells to store my paint, which I rejuvenate by spritzing with water and stirring with a mixing stick when it becomes too thick and hard to mix. I usually do this once a day.

I organize my colors starting with transparent paints on one side, opaque on the other side, and semi-transparent in between. I loosely follow a light-to-dark sequence for the transparent and opaque colors. I also have a few colors on my palette that I no longer use. I replace them as I find new colors that I like. To remove a paint color, I wait until it is rock hard and gently lift it out with a palette knife, taking care not to crack the palette.

I have opaque paints on the left and transparent on the right. I mix my colors in the center of the palette while I work.

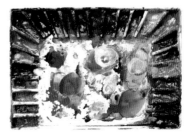

This is what my palette usually looks like at the end of the day! I will often clean the center before each new work day.

Brushes

I have a jar filled with various sizes and shapes of brushes that I've experimented with over the years. I recommend trying out different sizes of inexpensive brushes before investing in more expensive ones. Once you find yourself reaching for certain brushes over and over, you'll know which ones to upgrade. Slowly, you will build an arsenal of high-quality brushes without wasting money on ones you never use.

Brushes have natural or synthetic bristles, or a combination of the two. Natural bristles consisting of sable, kolinsky (also known as red sable), or squirrel hair are soft and pliable. By holding more water and paint than synthetic bristles, natural ones allow you to work longer without pausing to reload your brush. For that very reason, my two favorite brushes are my medium and small kolinsky round brushes.

Synthetic bristles made of man-made materials have their advantages as well. They are durable and less expensive than natural bristles. They also tend to make good "scrubbers," allowing you to remove paint.

Most watercolorists stick with round-, flat-, and oval-shaped brushes. Medium and large round brushes are by far the most versatile. Depending on how much pressure you apply, you can make wide to thin brushstrokes (A). Small round brushes are useful for making very fine brushstrokes (B), such as for hair or eyelashes. Flat brushes make nice, wide strokes (C) and are great for backgrounds and large areas. Oval brushes can make wide strokes or, turned sideways, very thin ones (D). For the projects in this book, I primarily used the first seven brushes shown. In parentheses, you'll find how I refer to some of the brushes in the book's projects.

To care for your brushes, clean them with lukewarm water and reshape with your fingers after each painting session. Never leave them sitting in water, or the bristles will lose their shape and ability to maintain a point. I lay clean brushes upside down on paper towels on my drafting table, which has a slight downward slant, to let the water run out.

A

B

C

D

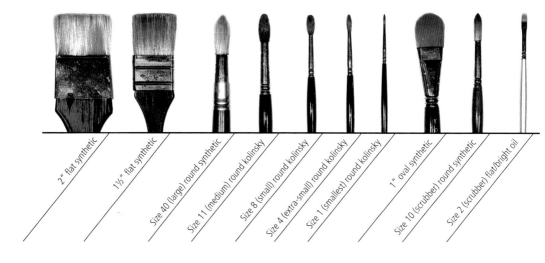

2" flat synthetic

1½" flat synthetic

Size 40 (large) round synthetic

Size 11 (medium) round kolinsky

Size 8 (small) round kolinsky

Size 4 (extra-small) round kolinsky

Size 1 (smallest) round kolinsky

1" oval synthetic

Size 10 (scrubber) round synthetic

Size 2 (scrubber) flat/bright oil

Paper

This is where I'm going to ask you to splurge and buy the best quality of watercolor paper you can afford. In my opinion, this is the one supply you can't skimp on.

Cold-press is the most popular texture for watercolor paper. It's also available in a coarser, rough texture and a smoother, hot-press texture. Cold-press paper falls in between the two with a texture that absorbs several layers of paint nicely.

For the projects in this book, I will be using a natural, 260-lb. watercolor cold-press paper. I use this type of paper almost exclusively. It has a smoother side and a rougher side, and I always paint on the rougher one.

In terms of weight, watercolor paper ranges from 90- to 300-lb. The most popular is 140-lb. I don't recommend using anything lighter than that as your paper can buckle and tear. Since 140-lb. paper is also prone to buckling, many artists stretch it before painting.

Stretching your paper involves soaking it completely and, while wet, laying it flat on a board. You can then stretch the edges and adhere it to the board with brown, gummed tape or staples. When the paper dries, it is tight and flat and stays that way when you paint.

I use 260-lb., cold-press paper because I don't have to stretch it, and it tends to be more durable for lifting and reworking paint. The downside is that it tends to absorb water quickly, meaning you have less time to mix paint on the surface. It is also more expensive than lighter-weight paper.

If your paper buckles, wet the backside of the painting and lay it flat overnight under heavy books. Be sure to place a clean sheet of paper between your painting surface and the books.

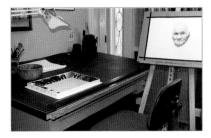

I keep my work area as neat as possible so I can move quickly from easel to table without much interruption.

Additional Supplies

You will also need a few other supplies before starting: a bowl or cup of fresh water; plenty of paper towels to dab your brush after dipping it in the water; a spray water bottle to freshen your paints when they start to dry out; an HB or 2B pencil for drawing your sketches; and a kneaded eraser. A paint tube wringer (the blue item in the photo) will save you money by squeezing every bit of paint out of the tube.

You'll also need liquid masking fluid, known as frisket, which comes in a bottle or jar. Frisket creates a rubberized barrier on your paper, or areas of your painting, that prevent the paint from adhering to it. Once your colors have dried, you can remove the frisket with a rubber cement or kneaded eraser and reveal the clean paper surface or painting underneath. I use frisket sparingly, mostly for wispy hairs and highlights.

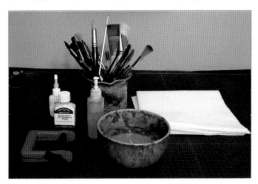

Workspace

My studio setup is very simple. It has nice, big windows for plenty of natural light during the day. I use natural light fluorescent bulbs in my overhead lights so I can work at night without a dramatic change in light. I use a large standing easel and a slightly elevated drafting table for painting. I paint upright on my easel when I'm using a larger brush and want my paint to mix and run. I work almost flat on the table when I'm using a smaller brush and want more control.

My dog, Malcolm, is a fixture in my studio!

WATERCOLOR TECHNIQUES

Like any new skill, watercolor takes lots of practice. The more you can experiment with your materials and tools, the quicker you will develop the skills needed to succeed.

Applying Paint

You can create different effects depending on whether you apply color to wet paper or dry paper. Dry paper absorbs paint quickly, creating harder, more defined edges (A). This is known as working "wet on dry." On the other hand, working "wet into wet" means wetting the paper before adding paint (B). The paper can be somewhat wet or completely soaked. The more soaked the paper, the softer and more delicate the effect. This technique is ideal for skies and subtle backgrounds.

Tip

Knowing how much water to add to the paint requires practice and patience, as the thickness and texture of each paint brand differs. As a general rule of thumb, I use 50% water and 50% paint for initial washes. I add more paint for dropping in color and more water for glazing.

Dropping in Color

Dropping in color, or "charging" as it is sometimes called, starts as a wet into wet technique. Then you add more color by touching a brush loaded with pigment to the wet wash. This extra pigment results in an exciting mix of color and edges.

Try it: Select two colors. Paint a swatch of your first color on dry or wet paper. While it is still wet, add a loaded brush of your second color. Watch as the heavier of the two colors pushes the other color around. Experiment with different ratios of water and paint. It doesn't matter which color you use first.

Mixing Colors

You can mix colors either on your palette or directly on your paper. Mixing on the palette gives you more control and a consistent color. Letting the colors mix directly on the paper allows the colors to mingle and mix in a random manner. You have less control, but the end result is more dynamic. The examples here illustrate the differences between the two techniques.

Try it: Select two colors. First, mix your colors on a palette and paint a swatch on your wet or dry paper. In a different area, wet a swatch of your paper and add one color. Then add the second color by brushing it near the bottom of the first. Watch the colors mix and mingle. Try moving them by tilting your paper in different directions.

Note the difference between mixing phthalo blue and raw sienna on (C) a palette and (D) on paper.

Viridian green and burnt sienna produce a different result when mixed on (E) a palette and (F) on paper.

Raw sienna dropped into permanent rose

Permanent rose dropped into French ultramarine blue

A mix of permanent rose and raw sienna with a phthalo blue glazing added over the right side

A swatch of French ultramarine blue with a quinacridone rose glazing added over the right side

Glazing Color

Glazing refers to layering washes of transparent color over completely dry transparent or opaque paint. You can add subsequent layers to achieve your desired effect, but be careful. Vigorous brushwork can disturb the bottom layers of your glaze, and, if you add too many layers, the effect can look muddy or opaque. Use only transparent paint for the glazing.

Special Effects

I use special effects to achieve texture, but I do so sparingly so they don't become gimmicky.

Blooms (G) are the outlined shapes that occur when a wet or damp brush touches drying paint. The water and paint from the brush pushes the pigment to the dry section of the paper, creating a hard-edged, irregular shape. Beginner painters are taught to avoid making blooms. However, I show students that blooms can be a wonderful textural element when created with a purpose. I use them anywhere I want a little surprise of texture.

I use a small spray bottle filled with water over an almost dry section of a painting to create a mottled effect (H). I use this technique for texture in my backgrounds.

The dry brush technique does not actually use a dry paintbrush but a slightly damp one loaded with paint. As you drag your brush along the paper, the paint will adhere to the raised surface of the paper but will not soak into the recesses. I use the effect (I) for textured clothing, hair, and backgrounds either by itself or as a final layer.

Many people use opaque white only for corrections or highlights, and some watercolor purists avoid opaque colors altogether. To me, this is too limiting. I believe in using whatever colors will make my paintings more interesting. This includes using titanium white over other colors (J) to add a touch of mystery or softness. The more water I use, the more transparent the white. Once dry, the original color peeks through. Feel free to experiment with different ratios of water and paint.

Finally, I use a stiff brush to lightly scrub or lift off areas of dry paint, most often when I need a strong highlight. An oil brush will create more prominent highlights (K), and a round synthetic brush will create softer ones (L).

Blooms

Spray

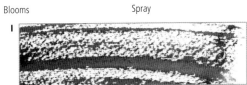

Dry brush

Opaque white

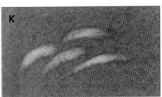

Scrubbing with a flat oil brush

Scrubbing with a round synthetic brush

CAPTURING PHOTOGRAPHIC REFERENCES

Some artists paint only from life, others from photographs, and still others work from both. Although I enjoy painting and drawing models from life, I mostly paint from photographs. I enjoy the versatility and ease of designing a painting's composition using digital images on the computer. In this book, I base each of the nine projects on a photographic reference that I captured and edited.

Once you're ready to move on from this book, I strongly suggest taking your own photographs to work from. Get to know your subject and find the poses that best represent their personalities. If possible, do a few sketches of your model and take notes.

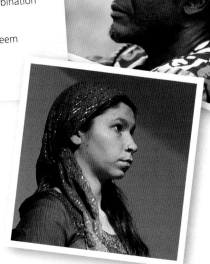

Here is a checklist of what makes a good reference photo:
- The photo is clear and sharp.
- You can easily see the details of your model's features.
- The lighting flatters your subject and creates a combination of shadows and light on the face.
- The pose is casual and candid. Posed shots often seem unnatural, and big smiles make the eyes squint.

A good-quality reference photo is a must for painters concerned with getting an accurate likeness.

Advantages and Disadvantages of Photographic References

Advantages
- You are able to work at your own convenience without the model.
- You can manipulate the design and composition of the digital image on the computer.
- You can compare all of the different poses and lighting you tried at once.
- You can combine elements from different photos to create a more interesting design.

Disadvantages
- You cannot study the model or move in closer for more detail.
- A photograph can distort images and color. Having experience in drawing from life or taking notes while working with your model can help you correct the distortions on the computer or in the painting stage.

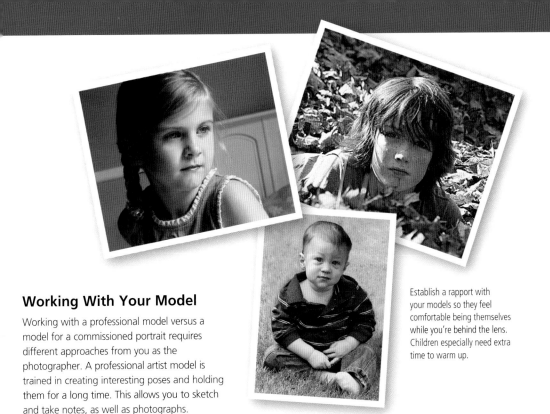

Working With Your Model

Working with a professional model versus a model for a commissioned portrait requires different approaches from you as the photographer. A professional artist model is trained in creating interesting poses and holding them for a long time. This allows you to sketch and take notes, as well as photographs.

Establish a rapport with your models so they feel comfortable being themselves while you're behind the lens. Children especially need extra time to warm up.

On the other hand, a subject for a commissioned portrait may need specific guidance on how to pose. They may feel uncomfortable being sketched and photographed, so take some time to get to know them before jumping into the photo session. This will help your subjects feel more at ease.

Whether you're working with an experienced or inexperienced model, it's important to have clear communication and a good rapport. When I'm working with a professional model, I start off by explaining my concept. Then we collaborate on a series of poses. We will often change clothing or location until we find the right setup.

Here are a few dos and don'ts of working with a professional model:

1. Do have your model sign a Model Agreement. This protects both you and the model by specifying price, usage, copyrights, and more.

2. Don't assume you and your model are on the same page. Take time to explain your concept and your goals for your time together. The more you communicate, the better the final results.

3. Don't come unprepared. Plan your props, lighting, and location ahead of time. Otherwise you will be paying your model to wait for you to set up.

4. Do give your model breaks. If you are sketching your model, make sure to check in every 20 minutes to see if he or she needs a break.

5. Do let the model determine what is physically possible. A model may be able to hold a difficult pose long enough for you to take a photo but not long enough for you to create a sketch.

Lighting Your Subject

Lighting is important for creating a mood, enhancing a setting, or simply highlighting an individual's features. You have a variety of options when it comes to lighting your subject: natural light, artificial light, and a combination of the two.

You can capture natural light in your photographs both indoors and outdoors. In fact, windows are my preferred method of lighting—north-facing windows in particular. Northern light refers to light entering the window without any direct sunrays. It is a soft, diffused light that is more flattering than direct sunlight or artificial lighting. The highlights are cool, and the shadows are generally warm. See the Portrait of a Young Woman project (page 22) for an example of using window lighting.

If you're taking photos outside, be mindful that bright afternoon sun can create harsh shadows. Morning or late afternoon, when the sun is less intense, will offer a softer, warmer light.

Artificial lights give you more control over the lighting and come in handy when natural light is not available. When I use this type of lighting, I keep my setup very simple and use only a lamp stand and a natural light fluorescent bulb.

To add interesting effects to your photos, try combining natural and artificial lighting, such as window light and an overhead light. In the painting stage, you'll have to carefully observe the different shadows and values each light creates, but it is worth the effort. See the Expressive Lighting project (page 50) for an example of using combination lighting.

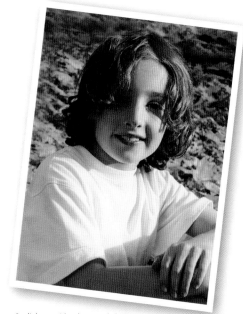

Sunlight provides dramatic lighting that lends itself to the spontaneous nature of watercolor.

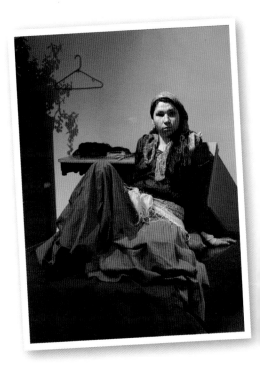

Rembrandt lighting, named after the artist himself, refers to placing artificial lights above and to one side of a model. This creates a nice shadow shape and a triangle of light on the cheek, as shown in this reference photo for the Creating a Story project (page 58).

Avoid using a camera-mounted flash. Directing a burst of light at your subject creates a flat, washed-out photo.

Take lots of photos. It's better to have too many good photos than to have to re-shoot from scratch. Take close-up and full-body photos of the same pose to make sure you have enough detail. Also, try to shoot at eye level to capture more detail in the eyes and face.

Editing Your Photos

Sometimes it is necessary to alter your photographs or combine elements from different photos into one image to create the desired composition. I do all of this on the computer using a photo editing program.

Cropping is also a useful photo editing tool. Creative cropping can also add interest to your work, change a focal point, simplify a busy setting, or save a failed composition. In addition to using the computer to crop photos, I use white mat corners (cut from an old mat) to play around with various ways to crop.

A B C

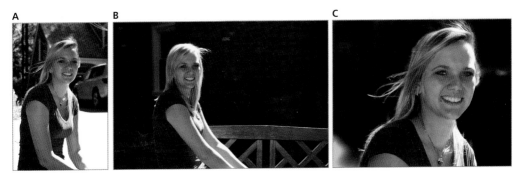

I took photos A and B during a recent shoot for a portrait commission. I liked the lighting in photo A and the model's expression in photo B. Photo C shows how I edited the two elements together, then re-cropped and simplified the background, to create the perfect image for the portrait.

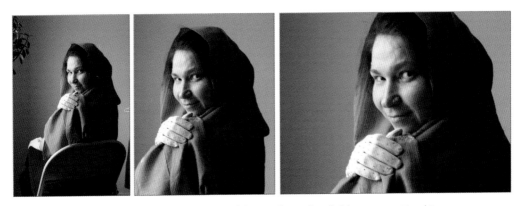

Cropping on the computer allows you to create several versions of the same photo until you find the one you want to paint.

DESIGN & COMPOSITION

Now that you have high-quality reference photos to paint from, you can get started, right? Not so fast. There is more to a good painting than achieving an accurate likeness with the help of your reference photos.

One of the most important skills an artist can learn is good design and composition. Learning how to design and compose your painting takes time to master, but here are several things to think about before you start.

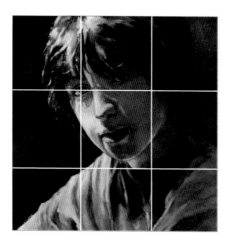

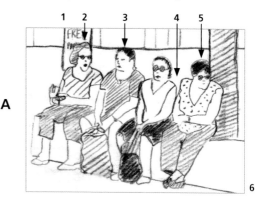

A

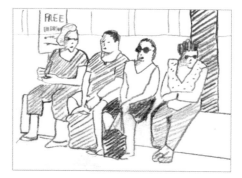

B

Define the Focal Point

The "rule of thirds" can help you place your focal point, which describes where you want your viewers to focus their attention. The rule of thirds is a compositional tool that divides an image into nine equal parts using two equally spaced horizontal lines and two equally spaced vertical lines. The focal point should fall along one of these lines or at an intersection of two lines. This creates more tension and interest in your composition than simply centering the subject. If you have many elements in your painting, it's even more important to make your focal point stand out.

Consider the Format

You will want to determine whether your format will be horizontal, vertical, or square. As you can see in these pencil sketches for the Elegant Woman project (page 38), the choice of format can change the feel of the design. The vertical composition includes the chair and background and is more formal than the other two. The horizontal composition feels more intimate, focusing on the subject's expression. The square format is a nice combination of the two.

Avoid Tangents

A tangent is when two or more shapes touch in a way that is visually bothersome. When creating a composition, it's easy to miss seeing tangents unless you are specifically looking for them. In sketch A, there are six tangents:

1. The top of the sign lines up with the edge of the paper.
2. The edge of the woman's face aligns with the edge of the sign.
3. The top of the woman's head lines up with the horizon line.
4. The arms of the two women share an edge.
5. The woman's face and the tree share an edge.
6. The line converges right at the corner of the paper.

In sketch B, I rearrange the shapes to avoid tangents by overlapping or moving objects.

VALUES

Most beginning students give me a blank look when I start talking about the importance of values in a painting. Value refers to how light or dark an element is in a painting. Strong design incorporates a mix of values, but too many values can make a painting busy.

A basic rule of thumb for combining values in a painting is "two-thirds, one-third, and a little bit." For example, the pencil sketch on this page consists of two-thirds medium values, which range from light-medium to dark-medium, one-third lightest value, and a small area of the darkest value, where I want my focal point to be. Try out different combinations of this rule for the same design and see how different the results can be.

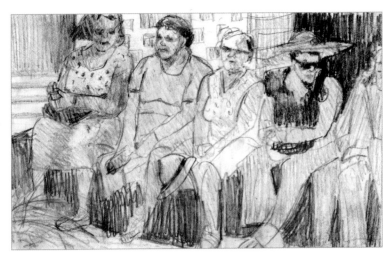

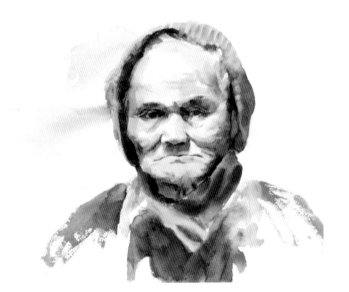

Achieving Accurate Values

Not only are values important in designing your composition, they are crucial to achieving a good likeness in your portraits. Seeing values accurately is a necessary skill that develops with much practice. You can try several methods to help you achieve accurate values in your paintings.

One method is to convert your reference photo from color to black-and-white. This eliminates the confusion of comparing values of different colors. I go back and forth between the color and black-and-white photos when I paint. Another is creating a one-color study before beginning your final painting. This gives you a better understanding of how light and dark the values of each area should be before tackling the same areas in full color.

To test if the values are right in your one-color study, take a piece of white paper and punch a "bullet hole" into it by pushing your pencil through the paper. Lay the hole you created over the area you want to evaluate. By surrounding the area with white, you can more easily discern its true value. Values are relative to their surroundings, which can create an illusion of a value being darker or lighter than it actually is.

BACKGROUNDS

Backgrounds are often an afterthought instead of planned in advance. This can result in a background that adds little to the painting or, worse, detracts from the main subject. Planning ahead will help integrate the subject with the background. These examples will give you a few ideas to think about.

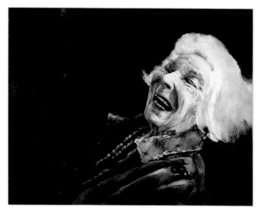

A bold color in the background can heighten a mood or strong personality. The red background in this painting was the perfect color to emphasize my friend's lively personality and fun nature.

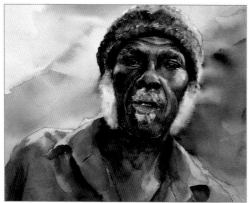

Neutral backgrounds complement skin tones without overpowering the figure. In this painting, the neutral background adds to the mood of the painting and does not compete with the bright colors in the hat.

Sometimes you want to include details in the background that tell something about the subject. In this painting, I included an outdoor market, but I chose to obscure the details by painting them loosely so that the figure remained the focal point.

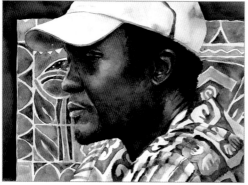

A graphic element in the background can add an interesting twist to a painting. Be sure the pattern enhances rather than overwhelms the painting. In this example, the figure dominates the painting with large high-contrasting shapes while the background blends seamlessly into his shirt pattern.

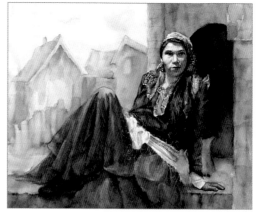

Including scenery can be a wonderful way to tell your subject's story. In this case, my model was dressed in old-world style clothing, so I wanted a fitting background to unify the painting. It was important to keep the background looser and less detailed than the foreground so that the painting would not be too busy or overworked.

BEYOND THE BASICS

Once you've established a solid design and composition and planned your background, you are ready to add excitement and energy to your painting. The examples below illustrate how movement, variety, white space, and contrast can put the finishing touch on a carefully planned painting.

Planning ahead doesn't mean that you won't make changes as you go along. A painting often evolves in unexpected and exciting ways. I've found it best to be flexible and open to changes during the painting process. The result is often a stronger painting.

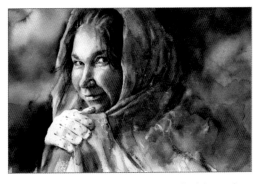

Diagonals can add movement to your painting and lead the eye where you want it to go. I used the folds of her scarf and the background to lead the viewer's eye around this painting.

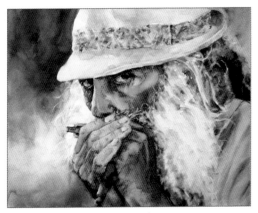

A combination of hard and soft edges adds interest and excitement to this painting. Hard edges are clearly defined ones, such as the edge of his hat. Soft edges are fuzzy and vague, like the edges of his beard against his shirt. Lost edges are when the edges of two or more objects are not discernible, such as with his beard and the background on the left. In this case, the two objects blend into one another.

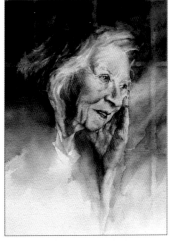

Use detail to emphasize your focal area while keeping other areas less descriptive. In this painting, I used detail in her face and hand but kept her shirt, hair, and the background loose.

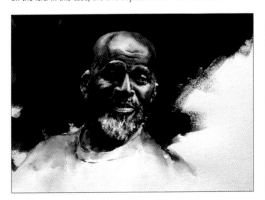

Leaving the white of the paper can create an exciting counterpoint to the painted area. An undone area gives this painting a spontaneous feel.

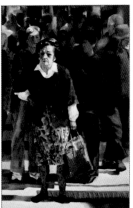

Use high contrast for your focal point and low contrast for your background to make your focal point stand out in an otherwise busy painting. In this painting, I wanted to make sure the woman in the foreground was not lost in the crowd. I painted her using high contrast, and I muted the background by using less contrast.

DRAWING YOUR PORTRAIT

Now that you have excellent reference material and a design and composition plan, you are ready to start your drawing. Before you begin, you may want to review the basics of drawing human features. Careful observation and an ability to translate what you see in the photo onto the paper will result in a better portrait.

There are two methods that I use to draw my image onto the watercolor paper: freehand drawing and grid. I use a grid for larger, more complicated drawings.

Drawing Freehand

When I paint from life, I always draw freehand. This means I am looking at my model and drawing what I see without the aid of a grid or other tools. Because of time constraints, it is sometimes necessary to draw quickly, with the goal of capturing a feeling or mood more than a detailed, accurate likeness. In a watercolor, the result is often loose and spontaneous.

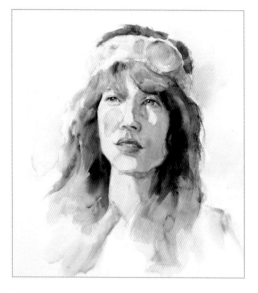

Practice is the only way to acquire strong drawing skills. There is no substitute or shortcut.

Using a Grid

A grid is a system of lightly drawn squares on your paper that correspond with squares on your reference photo. The objective is to observe what you see in each square on the photo and draw it in the corresponding square on the paper. When finished, you can erase the squares or incorporate them into the painting. This allows detailed drawing with less adjusting and erasing, resulting in a cleaner paper to paint on.

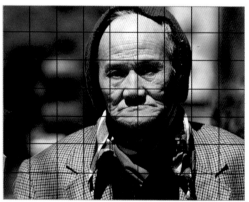

◀ The first image is the original photograph with a grid of squares drawn over it. The second image is the same grid lightly drawn on my watercolor paper. I can quickly draw what is in each square then erase the grid when finished.

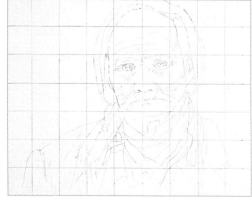

Mastering Facial Features

Careful observation is the only way to draw the features of the face from different angles. Learning specific rules, such as the eyes are in the middle of the face or the space between the eyes is approximately one eye length, will only help if you are drawing a forward-facing subject. Instead of relying on rules, use careful observation to break down each feature into simple shapes. This will result in more accurate drawings. These exercises will help you practice on individual features before attempting a full portrait.

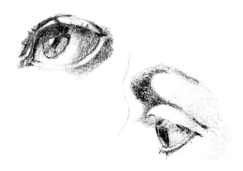

Eye Drawing Exercise

Eyes are spherical and, as such, they should be shaded to reflect their shape. In these drawings, you can see that the eye is shaded darker as it turns into the socket. Lids have depth to them and cast a slight shadow on the white of the eye. Eyelashes are not drawn individually but as a shape. Try drawing eyes from different angles in pencil before adding paint to the equation.

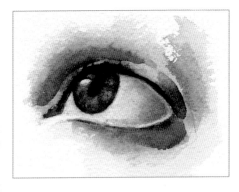

Eye Painting Exercise

After drawing the shape lightly onto my watercolor paper using an HB pencil, I use a small round brush and wet the white of the eye. I drop in a watery mixture of cerulean blue then add permanent rose in the corners. Once dry, I wet the iris and drop in raw sienna, phthalo blue, and burnt sienna. I let the colors mingle. When slightly damp, I drop in more color at the edges to darken. After the iris dries, I mix French ultramarine blue and sepia and paint the pupil and eyelashes. I wet the eyelids and add a mixture of permanent rose and raw sienna. I add a little French ultramarine blue and burnt sienna to darken the creases and bottom lid. Lastly, I add a touch of titanium white to the highlight in the eye with an extra small round brush.

Nose Drawing Exercise

Start with a basic prism shape (A). Place the apex of the shape at the bridge of the nose and the base across the widest part of the nostrils. Taper up toward the tip. Begin to erase your sketch marks and add shading to define the nostril and shadow areas (B). Try drawing noses from a variety of angles.

A

B

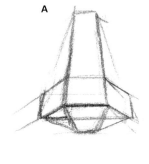

Nose Painting Exercise

To paint a nose, I start by applying a watery mixture of permanent rose and raw sienna over the entire area with a medium round brush. This will be the lightest skin tone. Once dry, I wet the shadow areas of the nose and drop in permanent rose, raw sienna, and French ultramarine blue. I let the colors mix. I add a little scarlet pyrrol to the tip and left side of the nose where it is warmer. Finally, I add a mixture of French ultramarine blue, burnt sienna, and permanent rose to define the nostrils.

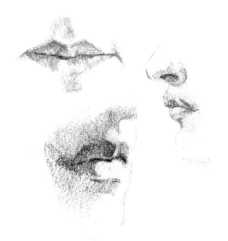

Mouth Drawing Exercise

Look at the upper and lower lips individually and draw them in three sections: left side, center, and right side. Both lips have dimension and shape, although the bottom lip is often fuller and lighter in color.

A common error in drawing or painting mouths is to make the outline of the lips too defined. Unless the subject is wearing lip color, the edges of the lips are most often soft and feathery.

Mouth Painting Exercise

To paint the mouth and the area around it, I use a medium round brush and add a wash of permanent rose and raw sienna over the entire area, including the teeth. I wait until it dries and add a light wash of French ultramarine blue over the shadow area on the right side of the face. I paint a watery mixture of permanent rose, burnt sienna, and a little French ultramarine blue over the entire lips. I soften the edges with a damp brush. While damp, I wet the shadow areas on the right and drop in quinacridone violet and French ultramarine blue. When dry, I mix French ultramarine blue and burnt sienna and paint the darkest area of the inner mouth. I water down the mixture and wash it over the teeth to tone them down.

Ear Painting Exercise

I start with a medium round brush and lay a wash of permanent rose and raw sienna over the entire area. Once dry, I mix French ultramarine blue into the wash and add it to the shadow area behind and inside the ear. Once dry, I add a wash of French ultramarine blue over the darker, smaller shadows. I mix French ultramarine blue and burnt sienna and paint the smallest, darkest recesses of the inner ear. I use the mixture to paint the hair above the ear. Lastly, I add a touch of scarlet pyrrol to the lobe and the top of the ear to give them warmth.

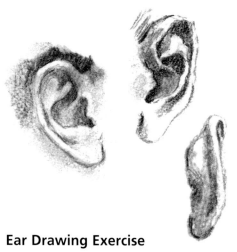

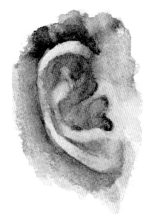

Ear Drawing Exercise

The ear is bowl-shaped with depth and dimension. There are clearly defined shapes and shadows that make up the ear. Observe each one carefully and draw what you see.

COLOR FORMULAS

Skin Tones

When painting skin, it is important to pay attention to a person's individual tone and temperature. The temperature is the perceived warmth or coolness. Below are several color combinations that I use to paint skin tones, although there are endless combinations possible. To make cooler skin tones, you can substitute phthalo blue for French ultramarine blue.

For each swatch, add the colors separately and let them mix on the paper. Try not to over mix the colors or they will appear muddy. Use the Row 1 color for the lightest skin tones and Rows 2 and 3 for the skin tones in shadow.

Fair Skin Tones

Row 1: Start with a mixture of permanent rose and raw sienna with approximately 70% water. Paint your first swatch.

Row 2: Add a little viridian green to half the mixture and paint the swatch on the left. Add a little French ultramarine blue to the other half and paint the swatch on the right.

Row 3: Do the same as Row 2 but add more of the blue and green to each swatch and use less water.

Medium Skin Tones

Row 1: Start with a mixture of terra rosa and raw sienna with approximately 70% water. Paint your first swatch.

Row 2: Add a little viridian green to half the mixture and paint the swatch on the left. Add a little French ultramarine blue to the other half and paint the swatch on the right.

Row 3: Do the same as Row 2 but add more of the blue and green to each swatch and use less water.

Dark Skin Tones

Row 1: Start with burnt sienna with approximately 70% water. Paint your first swatch.

Row 2: Add a little viridian green to half the mixture and paint the swatch on the left. Add a little French ultramarine blue to the other half and paint the swatch on the right.

Row 3: Do the same as Row 2 but add more of the blue and green to each swatch and use less water.

Neutrals

The key to fresh, beautiful neutrals is to let the colors mix on the page, as opposed to mixing them on your palette. Neutral backgrounds work well with portraits as they allow the subject to remain the focus of the painting. Below are several formulas that I use in my work. I mix each of these formulas with equal parts paint and water:

French ultramarine blue + burnt sienna

Quinacridone violet + sepia

Viridian green + permanent rose

Viridian green + sepia

Blacks

Black, straight from the tube, dries flat and lifeless. Instead, mix other colors together to create richer blacks. I mix each of these formulas with two parts paint and one part water:

French ultramarine blue + sepia

Viridian green + sepia

Quinacridone violet + sepia

Quinacridone violet + burnt sienna + phthalo blue

PORTRAIT OF A YOUNG WOMAN

In this painting, the neutral colors of the background and clothing allow the woman's features to be the focal point of the painting. The neutral palette also emphasizes her quiet mood.

Palette

Cerulean blue, French ultramarine blue, permanent rose, quinacridone magenta, raw sienna, sepia, titanium white, and viridian green

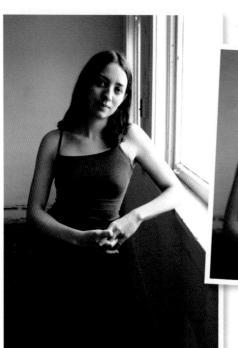

◄ My favorite way to photograph a model is using north-facing window light. The light is soft and flattering.

◄ I crop the original photo to create a very simple background and capture just enough of her body to create a pleasing triangular shape.

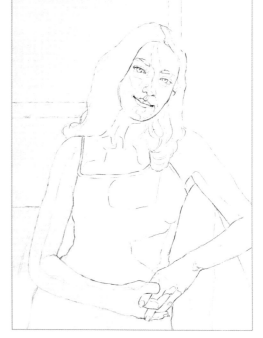

▶ **Step 1: Sketch** I work out most of my design decisions on the computer, so I skip the thumbnail sketch and jump right in to my 14" × 20" drawing. I lightly draw each shadow area using an HB pencil.

Tip

As watercolors dry, their intensity lightens by about 30%. To test colors, paint a sample and let it dry to make sure it is dark enough.

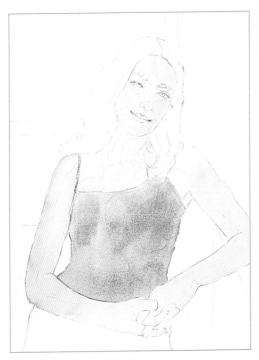

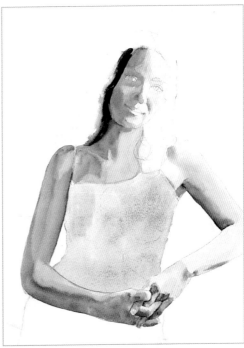

Step 2: First Washes With a flat 2" brush, I wet the skin tone areas. Then I lay in the first wash, a mix of permanent rose and raw sienna, over the entire area. I allow the color to go into her hair as you can often see the scalp through strands of hair. After this dries thoroughly, I apply a wash of cerulean blue and sepia with enough water to match the lightest light of her top. The cerulean blue leaves a nice granulated texture.

Step 3: Defining Values I paint the large shadow area as one shape by wetting the area with my 2" brush and floating in a watered down mixture of permanent rose, raw sienna, and a touch of French ultramarine blue. I then break down the shadow into smaller, darker values. I use the same colors but with less water, more pigment, and a smaller round brush. As I go along, I drop in individual colors where I perceive a change, a little extra permanent rose, for instance, in a warmer area. To compare the skin tones to my darkest dark, I paint a small area of hair with a mixture of French ultramarine blue and sepia.

▶ **Step 4: Facial Features** I cover the eye highlights with frisket. Once dry, I wet the iris and lightly drop in burnt sienna with my medium round brush. While damp, I add sepia around the edges. I mix sepia and French ultramarine blue for the pupil. Once dry, I remove the frisket and lightly add cerulean blue to the "white" of the eye. I dab the corners with permanent rose. I paint the lashes as one shape using sepia mixed with French ultramarine blue. I mix permanent rose and burnt sienna for the eyelid creases. I paint the ball of her nose with a mix of permanent rose, raw sienna, and French ultramarine blue. I add scarlet pyrrol to the tip but leave a little white underneath. I mix permanent rose and sepia for the nostrils. I paint the philtrum under the nose with a watery mix of permanent rose, raw sienna, and French ultramarine blue. I wet the mouth and drop in a watery mix of permanent rose and French ultramarine blue. I lift off a little paint for the highlight with a damp brush. I wet the eyebrows and float in a dark mix of French ultramarine blue and sepia with more pigment in the centers. I soften the edges with a damp brush.

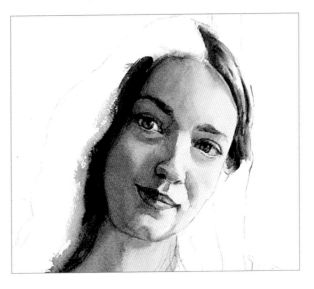

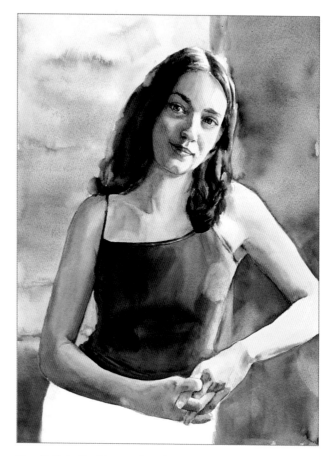

Step 5: Hair, Clothing, and Background I wet the background, load my 2" brush with color, and touch it to the wet paper. I loosely lay in washes of cerulean blue, viridian green, sepia, and a touch of raw sienna. The color spreads and mixes in a wonderfully uncontrolled way. I let the background dry and then start the hair. For the lighter areas, I use burnt sienna, sepia, cerulean blue, French ultramarine blue, and a touch of viridian green. I wet the area and drop in the colors, letting them mingle on the paper. For the darker areas, I use a very concentrated mix of French ultramarine blue and sepia, with touches of burnt sienna.

Hand Detail Painting the hands is very similar to painting the rest of the body, except I am dealing with smaller areas of value changes. I use the same mixture of French ultramarine blue, permanent rose, and raw sienna as I did for her face and arms. I add more blue in the shadows and more permanent rose and raw sienna in the warmer areas.

24

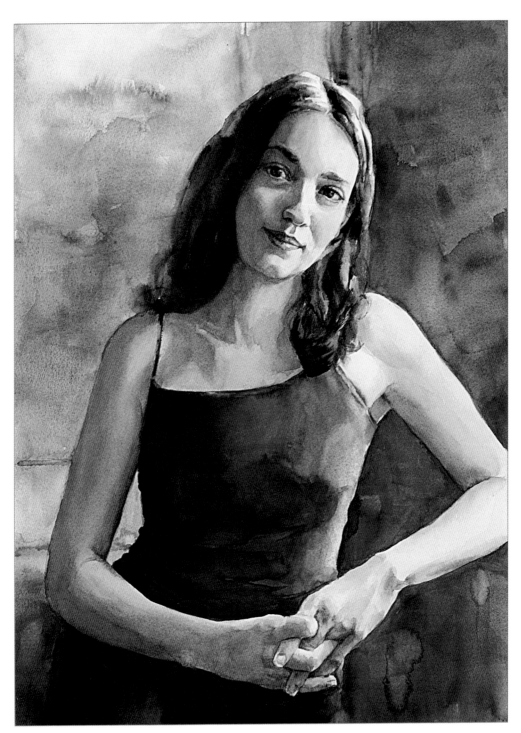

Step 6: Finale I finish her clothing by applying a concentrated mix of French ultramarine blue and sepia in the shadows and touches of cerulean blue and viridian green in the lighter areas. I lose some of the edges of her clothing and hair into the background. For the finishing touches, I skip around, adding a touch of color here and there, softening areas, and refining features and hair. I add contrast and refine her hands. I use titanium white, which is an opaque paint, to soften edges where needed, lighten areas, and add highlights (such as in the eyes and on the lips). I darken additional areas of the background with washes of French ultramarine blue, sepia, and viridian green.

SUNNY DAY

Painting children requires a softer touch. The skin of a child is very smooth, making it important not to overemphasize shadows and creases you may see in a photo. The challenge is to achieve accurate values and a likeness with as few layers as possible.

Palette

Burnt sienna, cerulean blue, French ultramarine blue, permanent rose, quinacridone violet, raw sienna, scarlet pyrrol, sepia, titanium white, and viridian green

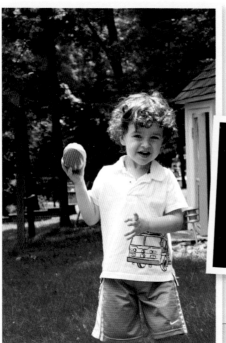

◀ The strong sunlight on the little boy's hair is a perfect opportunity to play with color and contrast, but the original photo includes too much information.

◀ I crop and edit to focus on the boy's happy disposition and wonderfully curly hair. I will need to balance the painting with a strong background and a subtle handling of the skin tones and white shirt.

▶ **Step 1: Sketch** As I draw the 15" × 13" image on watercolor paper, I set the figure slightly off center for a stronger composition. I add frisket to the highlights in the hair.

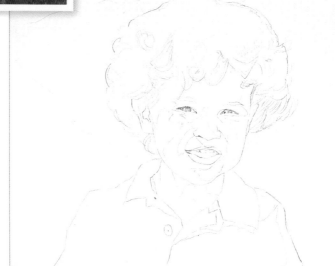

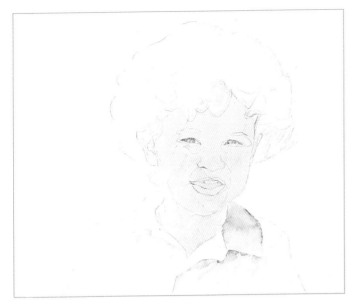

◄ Step 2: First Washes With a 2" flat brush, I lay in a light mixture of raw sienna and permanent rose over his face and up into his hair. I wet the shadow areas of his shirt and gently drop in watery mixtures of quinacridone violet, raw sienna, permanent rose, and cerulean blue, keeping the shadows very light and soft.

On a young child's face, blues and purples can look like bruises if applied too heavily. I will sometimes substitute green for shadows instead.

► Step 3: Skin Tones I wet small areas of the face and drop in watery mixtures of permanent rose and raw sienna. I add scarlet pyrrol to warm the skin and viridian green to cool. I paint a small section of his hair and the background with saturated mixtures of sepia, burnt sienna, and a touch of French ultramarine blue.

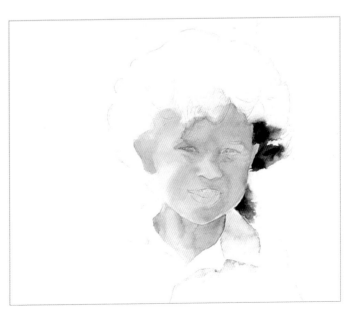

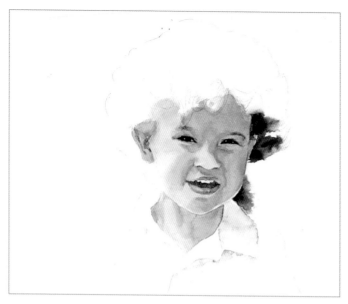

◄ Step 4: Facial Features Using a medium round brush, I wet the area under the nose and drop in scarlet pyrrol on the left and burnt sienna on the right for the nostrils. I wet the lips and drop in permanent rose, then raw sienna. I blot out highlights with a small dry brush. Painting around the teeth, I randomly drop in sepia and permanent rose inside the mouth. I drop scarlet pyrrol and a little burnt sienna into wet shapes to define his ears.

Eye Detail I paint the eyes in an imprecise manner using a medium round brush. I wet the area and drop in a mixture of sepia and French ultramarine blue. I wet the eyebrow area, add a watery burnt sienna/sepia mix, and whisk a small round brush over the wet area to create a soft, subtle brow.

Tip

Use more pigment in the shadows and more water in lighter areas.

► Step 5: Hair Using my medium round brush, I take one section of hair at a time and alternately wet and drop in colors. I use raw sienna, permanent rose, burnt sienna, scarlet pyrrol, sepia, quinacridone violet, and French ultramarine blue. I leave large areas of the paper to depict the lightest sunlit areas. I reserve the sepia and French ultramarine blue for the darkest areas. Once dry, I remove the frisket and soften the hard edges with a damp round brush.

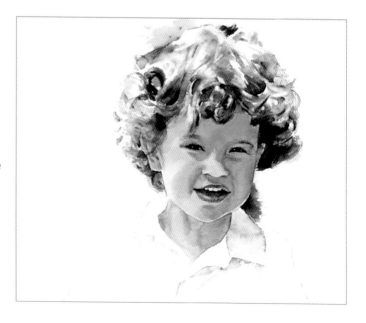

◄ Step 6: Background I place the painting upright on my easel and turn it 90 degrees to paint the background. I load my 2" brush with color and let it run down the paper, away from the boy. I work with one color at a time (sepia, French ultramarine blue, scarlet pyrrol, viridian green, and raw sienna) and let them mix and run together. I add more water, when needed, to move the paint. After it dries, I rotate the paper 180 degrees to paint the other side.

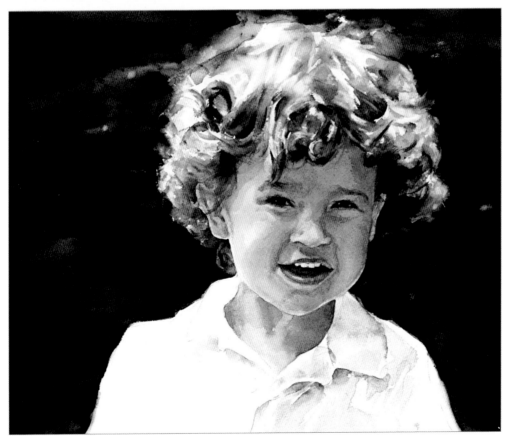

Step 7: Finale I go back into the shirt and slightly darken the shadows with quinacridone violet and raw sienna. For the brightest areas, I leave the paper white. I add slightly more shadow and color to his skin, and, finally, I add a few wispy hairs with an almost-dry brush and titanium white.

WAITING

This painting has the feel of anticipation—a young girl waiting to go outside and play. I'll use contrast, composition, and background to help tell the story.

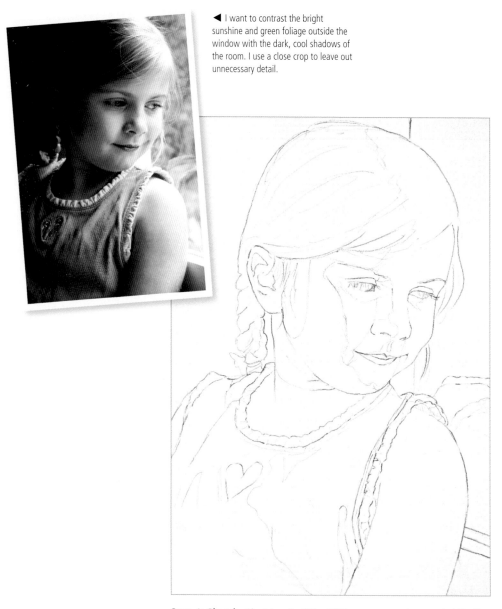

Palette

Cerulean blue, French ultramarine blue, green gold, Hooker's green dark, permanent rose, quinacridone magenta, quinacridone violet, raw sienna, scarlet pyrrol, sepia, titanium white, and viridian green

◄ I want to contrast the bright sunshine and green foliage outside the window with the dark, cool shadows of the room. I use a close crop to leave out unnecessary detail.

Step 1: Sketch After I draw the 12" × 16" image on watercolor paper, I add liquid frisket in the highlight areas of her hair, eyes, lips, and shirt ruffle.

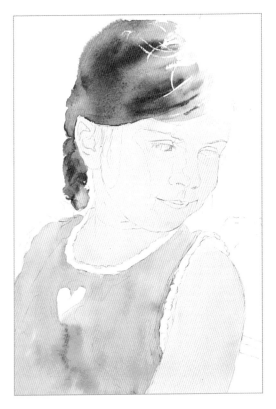

◄ **Step 2: First Washes** With a 2" flat brush, I wet the entire face and arms and add a light mixture of raw sienna and permanent rose. I wet the darker area of her hair and drop in burnt sienna, sepia, and raw sienna. I let these colors mingle. I soften the edges with my medium round brush before the paint dries. Once dry, I rub off the frisket from her eyes and hair. I paint her shirt with a watery layer of permanent rose.

▶ **Step 3: Shadows and Values** Using my medium round brush, I wet the large facial shadows and drop in French ultramarine blue, raw sienna, and permanent rose, taking care not to leave hard edges. I add a little quinacridone violet to darken. I add a watery mixture of permanent rose, raw sienna, and French ultramarine blue to define the shadows on the light side of her face and above her upper lip. I wet the shadow areas of the arms and add a mix of raw sienna and permanent rose. I then drop in viridian green and French ultramarine blue. I darken her hair with sepia and burnt sienna, softening the edges with a damp medium round brush. To compare the values of the background and skin tones, I wet a small section next to her face and drop in viridian green and raw sienna.

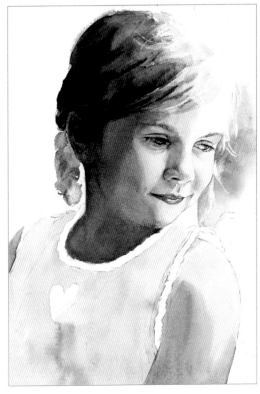

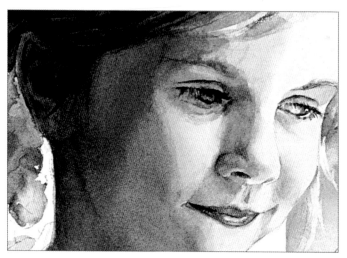

◀ Step 4: Facial Features

With my medium round brush, I add scarlet pyrrol to her cheeks and nostrils. I switch to my small round brush and paint her lips using permanent rose. I add a touch of raw sienna in the center and quinacridone violet in the left corner. I wet the irises and drop in cerulean blue and raw sienna, adding small dabs of French ultramarine blue to the outer edges. I paint the eyelashes with a mixture of French ultramarine blue and sepia, then define the eyelids with a mixture of permanent rose, raw sienna, and French ultramarine blue. I use a mix of permanent rose and sepia to define her nostrils. I paint the shadows of her ear with a mix of French ultramarine blue and quinacridone violet, keeping the edges soft and blurry. Once dry, I remove the frisket from the facial highlights.

It's important to think about how much detail to include in your painting and why you are including it. I chose to include a lot of detail on the ruffles of her shirt for rhythm and repetition, but I painted the rest of the shirt in a loose manner.

▶ Step 5: Clothing

I add another wash of permanent rose to her shirt. I concentrate pigment in the shadow areas and add quinacridone violet to darken. For the ruffle, I add a wash of viridian green and green gold. Then I remove the frisket and wet each shadow area, dropping in various concentrated mixtures of green gold, viridian green, Hooker's green dark, and cerulean blue. I include a variety of hard and soft edges. I wet the heart shape and wait for it to become only slightly damp before dropping in permanent rose, scarlet pyrrol, cerulean blue, quinacridone violet, and Hooker's green dark. I use my small round scrubber to pull off paint for highlights.

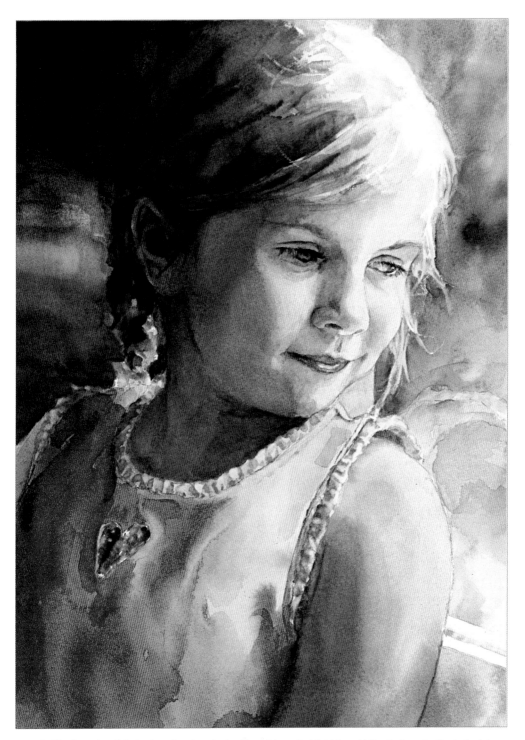

Step 6: Finale With a 2" flat brush, I add washes of quinacridone violet on the left. I follow with French ultramarine blue in the darker areas. I add a few brushstrokes of titanium white to break up the purple. For the window scene, I wet the entire area and randomly drop in my greens and raw sienna. I switch to my medium round brush and loosely paint her reflection using the colors from her shirt and skin tones. I paint the window frame with a watery mix of quinacridone violet, raw sienna, and permanent rose. I let these colors mingle. Finally, I use a nearly dry, extra small round brush to paint wisps of hair in titanium white.

WORKING WITH BOLD PATTERNS

This painting incorporates a bold, graphic background with a central figure. The challenge will be to balance the patterned background with the prominence of the figure in the foreground.

Palette

Cerulean blue, French ultramarine blue, permanent rose, quinacridone magenta, raw sienna, sepia, titanium white, and viridian green

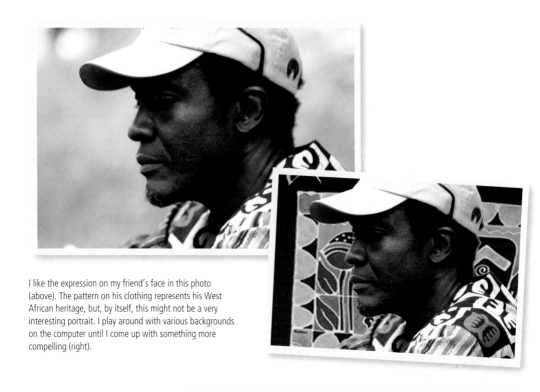

I like the expression on my friend's face in this photo (above). The pattern on his clothing represents his West African heritage, but, by itself, this might not be a very interesting portrait. I play around with various backgrounds on the computer until I come up with something more compelling (right).

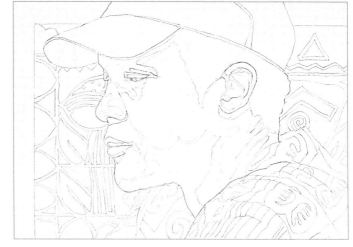

▶ **Step 1: Sketch** I transfer the 16" × 11" sketch to my watercolor paper and include as much detail as I can.

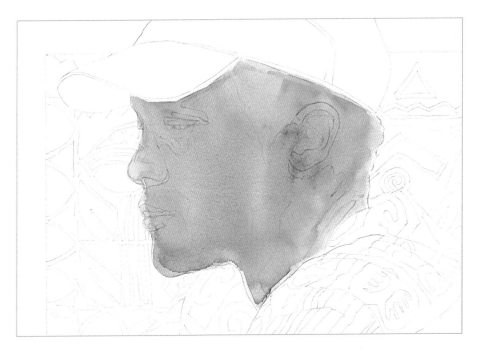

Step 2: First Wash Using my large 2" brush, I start with water only and then drop in a mixture of burnt sienna and viridian green over his face and hair. I match this value to the lightest area of his skin.

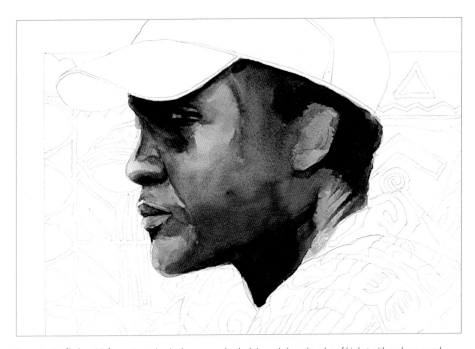

Step 3: Defining Values I wet the shadow area under the brim and along the edge of his hat with my large round brush. Then I drop in concentrated mixtures of viridian green, French ultramarine blue, sepia, and burnt sienna. I add extra cerulean blue to cooler areas and viridian green and burnt sienna to warmer ones. I roughly define the eyes and nose with a mix of sepia, French ultramarine blue, and burnt sienna and the mouth with a wash of French ultramarine blue and quinacridone magenta. I'm not adding any detail at this point.

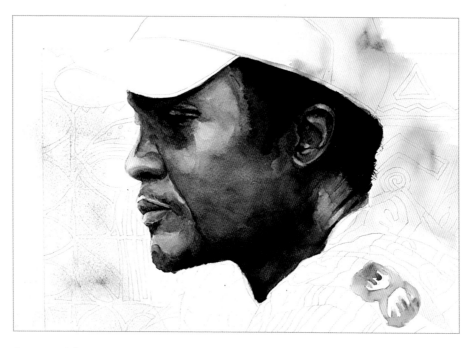

Step 4: Facial Features To add definition to his face, I increase contrast in the shadow areas using a concentrated mix of sepia and French ultramarine blue. I apply color along the jaw line, in the shadow along the cap, in his hair, and under his nose and ear. I define the shape of the eye on the right and let the color bleed into the shadow. I run a bead of water along the creases in his neck and drop in a mixture of burnt sienna and sepia. I am careful to vary the intensity of the lines so they look more realistic. Lastly, I add washes of cerulean blue and raw sienna to the background.

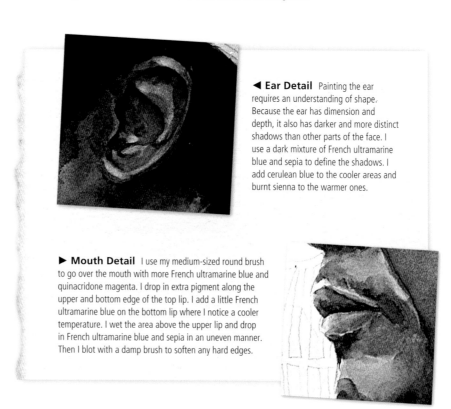

◀ **Ear Detail** Painting the ear requires an understanding of shape. Because the ear has dimension and depth, it also has darker and more distinct shadows than other parts of the face. I use a dark mixture of French ultramarine blue and sepia to define the shadows. I add cerulean blue to the cooler areas and burnt sienna to the warmer ones.

▶ **Mouth Detail** I use my medium-sized round brush to go over the mouth with more French ultramarine blue and quinacridone magenta. I drop in extra pigment along the upper and bottom edge of the top lip. I add a little French ultramarine blue on the bottom lip where I notice a cooler temperature. I wet the area above the upper lip and drop in French ultramarine blue and sepia in an uneven manner. Then I blot with a damp brush to soften any hard edges.

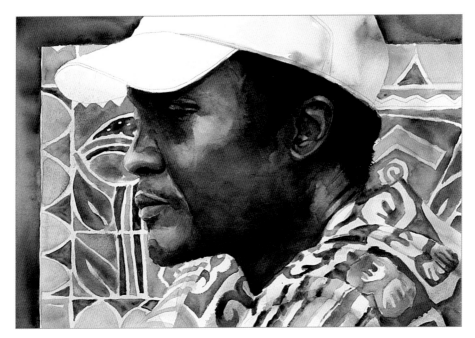

Step 5: Clothing and Background I paint each background shape separately by wetting the area and dropping in one of the following: raw sienna; sepia; a mixture of raw sienna and burnt sienna; or a very light mixture of sepia and raw sienna. The background colors need to be slightly lighter and have less contrast than the figure. To indicate the shadows of the shirt's folds and wrinkles, I add washes of cerulean blue. I let this dry and continue painting the shapes on his shirt.

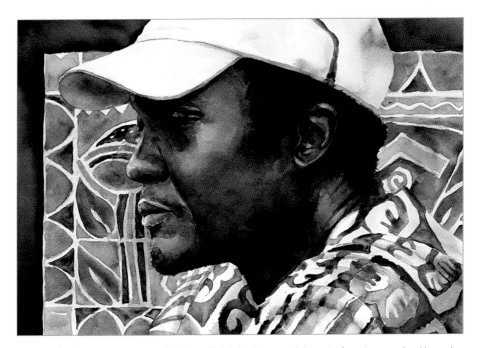

Step 6: Finale I wet the entire area of the hat and lightly drop in a watered-down mix of raw sienna, cerulean blue, and sepia. I add more sepia to the shadow area under the brim. I darken select background shapes with another wash of color. The man's face isn't standing out enough, so I add a light wash of sepia to the background along the side of his profile. I indicate the lashes of the eye on the left with a simple stroke. To add a small highlight to his nose, I take a tiny bit of titanium white with very little water and touch the brush to the paper one or two times. Finally, I add the sepia stripe to his hat.

AN ELEGANT WOMAN

Older men and women are some of my favorite subjects to paint. I love the character and confidence they exude. Window lighting brings out the softness of their skin and highlights the character lines. In this painting, I want to capture the quiet dignity of my model, whose clothing, jewelry, and features reflect her Indian culture and background.

Palette

Burnt sienna, cerulean blue, French ultramarine blue, manganese blue, quinacridone magenta, quinacridone rose, quinacridone violet, raw sienna, scarlet pyrrol, sepia, terra rosa, titanium white, and viridian green

◀ The original photo has a busy background that I will simplify.

Tip

Developing small thumbnail sketches is a useful way to work out a composition. The small size helps you see the simple shapes and values. I decide that the vertical format works best, so I will combine elements from the first and third sketches.

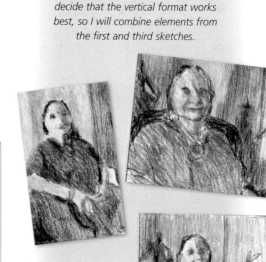

◀ **Step 1: Sketch** The drawing is large, 22" × 30". The necklace is culturally relevant to my model's heritage, so I want the drawing to be as accurate as possible. I add liquid frisket over the highlights of all the jewelry and the watch.

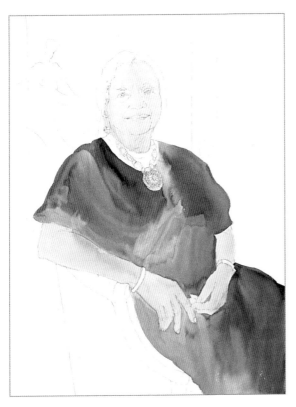

◄ Step 2: First Washes Working upright and using a 2" flat brush, I lay in a light mixture of raw sienna and permanent rose over her face and hands. I add a wash of quinacridone violet and manganese blue over her dress.

Tip

For large areas, it's best to work quickly and with a large brush. Avoid the temptation to go back into the color while it is drying, or you may lose the freshness of the wash.

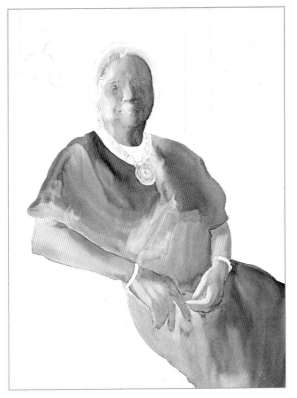

◄ Step 3: Adding Shadows Using my medium round brush, I define the shadow area on the right side of her face with terra rosa and raw sienna. Then I quickly add viridian green and burnt sienna. I let the colors mingle and push the paint slightly where needed. I do the same with her arms and hands.

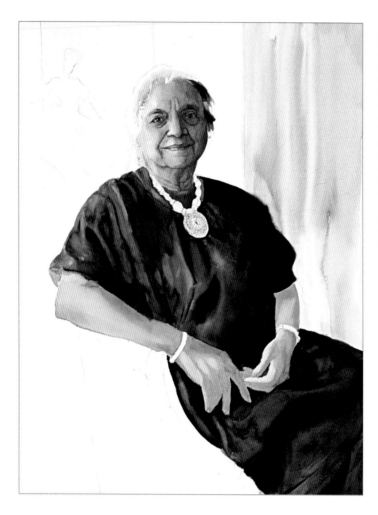

◀ Step 4: Clothing I paint her dress using both a 2" flat brush and a large round brush. I use mixtures of sepia, quinacridone violet, manganese blue, and French ultramarine blue. I continue to drop in color while the area is wet, creating blooms and interesting patterns. For the darker areas, I add a more concentrated mix of sepia and French ultramarine blue. Once dry, I sparingly add titanium white to simulate the shine of the fabric. With a small round brush, I paint the red top using scarlet pyrrol, terra rosa, and quinacridone violet. I add a light wash of sepia to the background to compare values.

Tip

Painting realistic-looking fabric requires careful observation of the direction and shapes of the folds. Be sure to include a variety of hard and soft edges.

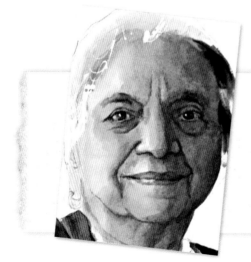

Facial Detail I lay the painting flat and use a small round brush to paint the irises with sepia and raw sienna, leaving the highlight. For the creases and nostrils, I wet the area and drop in various mixtures of burnt sienna, raw sienna, quinacridone rose, terra rosa, and viridian green. For darker areas, I use less water. I paint her lips with terra rosa and quinacridone violet and blot the edges with a damp brush. I wet the eyebrow area and swipe in sepia, adding more pigment to the edges. I add the darkest part of her hair with sepia and French ultramarine blue.

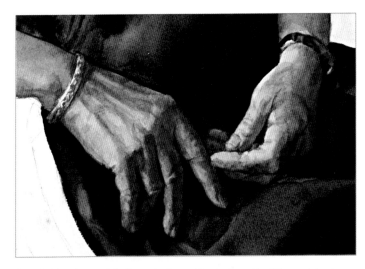

Step 5: Hands I carefully observe the shapes of the shadows and wet the area. I drop in various mixtures of French ultramarine blue, quinacridone violet, quinacridone rose, and viridian green. I touch the edge of the shadows with scarlet pyrrol. I paint the bracelet by wetting the darker shapes and dropping in viridian green, sepia, scarlet pyrrol, and raw sienna. I paint the watch with a concentrated mix of French ultramarine blue and sepia and drop in raw sienna while wet. I rub off the frisket to reveal the highlights and soften the edges with a damp brush, gently rubbing the edge of the paint.

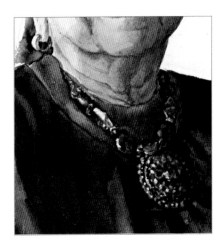

Step 6: Necklace and Earring I paint the entire medallion of her necklace using different concentrations of sepia and a medium round brush. For stronger color, I use more pigment and less water, and vice versa. I add a touch of raw sienna to the center. I use a small round brush to paint the purple stones with quinacridone violet and French ultramarine blue. I paint the topaz stones with a mix of raw sienna, burnt sienna, and sepia dropped into wet shapes. I wet the remaining pieces and drop in sepia. I paint her earring with several quick strokes using a mix of burnt sienna and raw sienna. Once dry, I remove all the frisket and soften the edges.

Tip

You likely won't ever use a solid color to paint metal jewelry. Because of its reflective nature, the metal will often include a variety of colors from its surroundings.

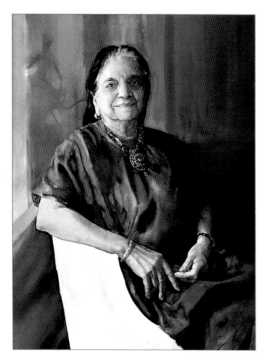

◄ Step 7: Background I place my painting upright and use a 2" flat brush loaded with mixtures of burnt sienna, raw sienna, scarlet pyrrol, and quinacridone violet. I start at the top and brush down to the middle. I take cerulean blue and brush horizontally to the right. While wet, I paint an obscured shape of a sculpture in the upper left corner with a watery mix of burnt sienna and sepia. I purposely keep the edges soft. Once dry, I go over the entire background with a 50/50 mix of water and titanium white to soften the strokes and mute the colors. I paint diagonal strokes with various strengths of sepia and raw sienna in the lower left.

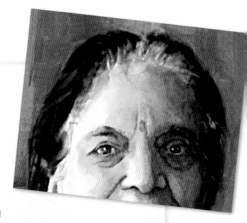

Hair Detail I use a medium round brush to wet the lighter areas of her hair and drop in cerulean blue and a very watery sepia. I leave the white of the paper for highlights. While wet, I blot the edges with a damp brush to soften. I switch to a large round brush and use mixtures of burnt sienna, sepia, and French ultramarine blue for the darkest areas. I paint each area as a shape, softening some of the edges and leaving others hard and defined. I go over the lighter areas with a few strokes of titanium white, following the direction of her hair. I create the red oval on her forehead, known as a *bindi*, by wetting the area and dropping in a very watery mix of scarlet pyrrol and quinacridone violet.

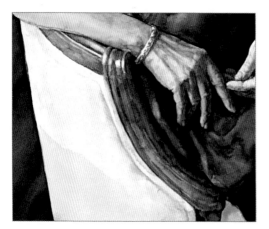

◄ Step 8: Chair Using a 2" flat brush, I paint the body of the chair with a light wash of burnt sienna and sepia. I add extra paint to darken the lower half. While damp, I drop in extra sepia for the seam. I paint the wooden trim with several washes of burnt sienna and darken it with sepia and French ultramarine blue. I leave the white of the paper for the shiny highlights of the wood.

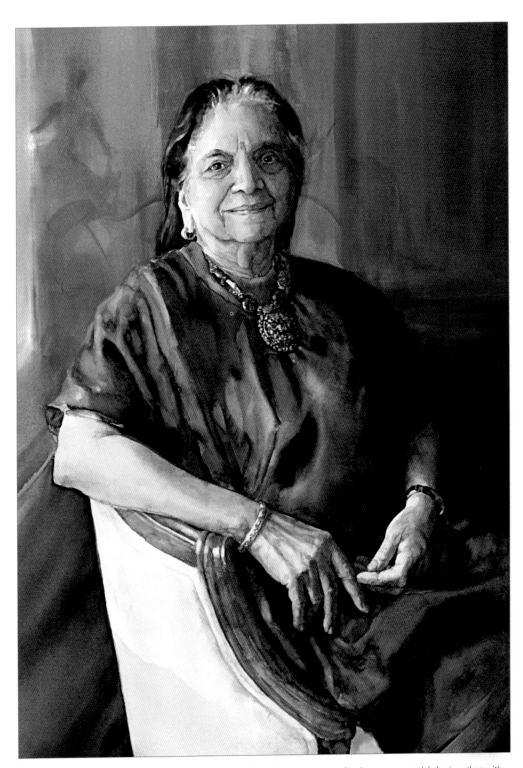

Step 9: Finale I make several adjustments to the background by adding more titanium white in some areas and darkening others with sepia. I touch up a few areas of her face and hands with an almost-dry brush and very little color to define some of the shadows. Lastly, I add a few wisps of hair with sepia on an almost-dry, extra small round brush.

LAST VISIT

While working with my model, I was immediately drawn to the expressiveness of his face and the ease of his pose. A story emerged in my mind of an older gentleman visiting a beloved person or place. My goal was to create a sense of recollection, while letting the viewer create his or her own story.

Palette

Cadmium red, cerulean blue, French ultramarine blue, permanent rose, quinacridone magenta, raw sienna, sepia, scarlet pyrrol, and viridian green

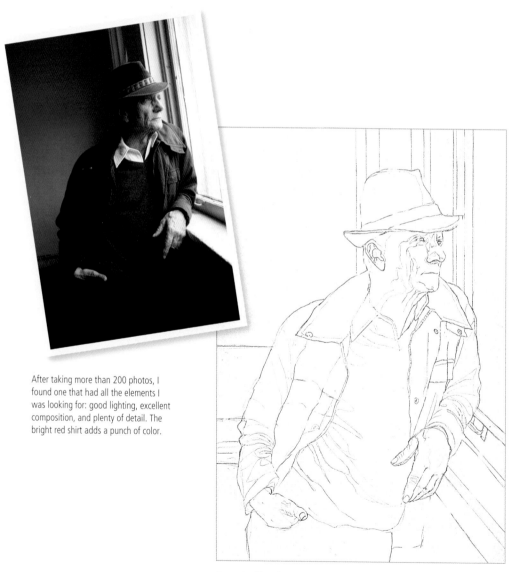

After taking more than 200 photos, I found one that had all the elements I was looking for: good lighting, excellent composition, and plenty of detail. The bright red shirt adds a punch of color.

Step 1: Sketch I draw the 16" × 22" image on watercolor paper and include the shadows and highlights. Before I start painting, I add a tiny bit of liquid frisket to the highlights in the eyes and along the tip of the nose.

▶ Step 2: First Washes With a 2"
flat brush, I lay in a light mixture of raw sienna
and permanent rose over his face and hands.
I paint the light shadows on his shirt collar
with cerulean blue, raw sienna, and permanent
rose. I start on the red sweater with a mix of
quinacridone magenta and scarlet pyrrol to
make sure the red works with the skin tones.
Then, to compare my darkest dark to the other
values, I paint the collar of his jacket on the
left with a mixture of French ultramarine blue
and sepia.

◀ Step 3: Facial Features
Using my medium round brush, I wet
the large facial shadows and drop in
my colors: French ultramarine blue, raw
sienna, and permanent rose. I use my
brush to push around the colors, taking
care not to mix too much. I add a touch
of scarlet pyrrol to the warm edge of
the shadow where it meets the light.
I add a little quinacridone magenta
and scarlet pyrrol to his nostrils, cheek,
and chin. I lightly indicate his lips with
a mix of permanent rose and French
ultramarine blue dropped into a thin
line of water.

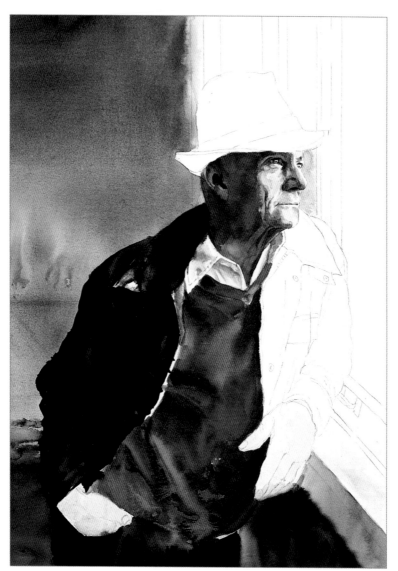

◄ Step 4: Clothing and Background

I move my painting to the easel so it is almost upright. This allows the paint to run and mix on the paper. I start at the top of the red sweater and work my way down using quinacridone magenta and scarlet pyrrol. While the paint is wet, I drop in darker areas of French ultramarine blue, quinacridone magenta, and scarlet pyrrol. I wet the left side of the background and drop in cerulean blue, raw sienna, viridian green, and sepia. Once it dries, I paint the dark side of his jacket and pants using a saturated mix of French ultramarine blue, sepia, and cerulean blue. I use more sepia and French ultramarine blue in the darker jacket areas. I begin the other side of the background using raw sienna, French ultramarine blue, and sepia.

Eye Detail I wet the irises and drop cerulean blue in the centers. I add small dabs of French ultramarine blue to the outer edges and let it mingle with the cerulean blue. Once this dries, I remove the frisket and add a little sepia and French ultramarine blue to create his pupil and upper eyelashes.

► Step 5: Clothing and Background, Continued I proceed with the rest of the background using a wash of cerulean blue and raw sienna. After it dries, I add definition to the window, frame, and sill with colors already mixed on my palette: French ultramarine blue, sepia, scarlet pyrrol, and raw sienna. Once the background dries, I paint the rest of the jacket with French ultramarine blue, sepia, and a little raw sienna. I add more sepia and French ultramarine blue to the shadow areas below the collar. To give the jacket a worn look, I dip a round brush scrubber in water, dab it on a paper towel, and lightly scrub the paint from small areas. For the thread on the collar, pockets, and cuff, I wet a thin line and drop in a little French ultramarine blue in an irregular manner. I drop in burnt sienna for the buttons. I paint the zipper by adding a French ultramarine blue and sepia mix to the spaces in between the metal and the shadow areas. I add sepia to indicate his hair.

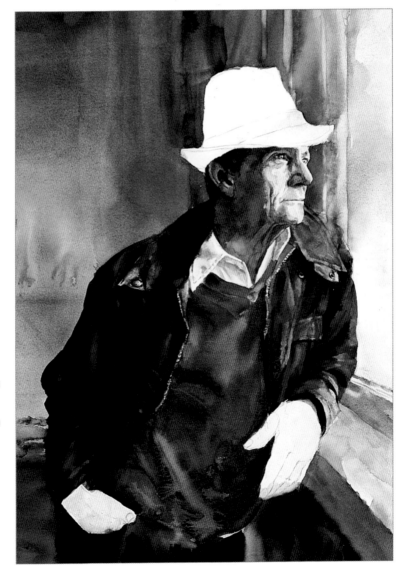

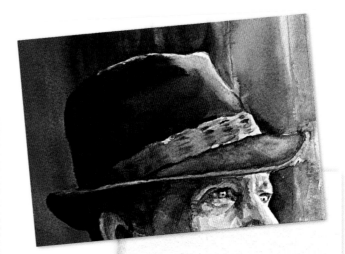

Paint older skin with restraint. Your portrait will not be very flattering or realistic if you try to paint every character line and wrinkle or if you paint them too dark. Select only a few of the prominent lines to paint.

Hat Detail Using my large round brush, I wet the areas above and below the hatband and drop in a mix of cerulean blue and sepia. I use extra sepia on the left, as well as along the seam and underside of the brim. I add a touch of cadmium red on the brim. For the band, I drop in raw sienna and a little sepia. While it's wet, I create the textured lines using a medium round brush and a mix of sepia and cerulean blue.

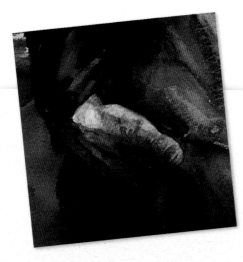

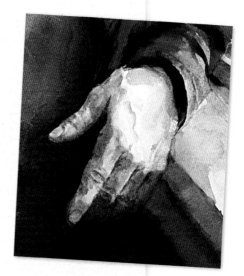

Hands Detail I lay down several washes of raw sienna, permanent rose, and French ultramarine blue. For the hand resting on the right, I use a more delicate touch and less blue. For the other, I add more blue until the value almost matches the pants. This creates a "lost edge," which you can read about on page 17. When something is in shadow, such as this hand, the edges are fuzzier and will have less contrast. I wet the shape or line of the wrinkles and veins and carefully drop in watered-down color. The values of the wrinkles and veins are only slightly darker than the surrounding areas. If the color is too dark, I dab it with a damp brush. I paint his fingers as a series of simple shapes.

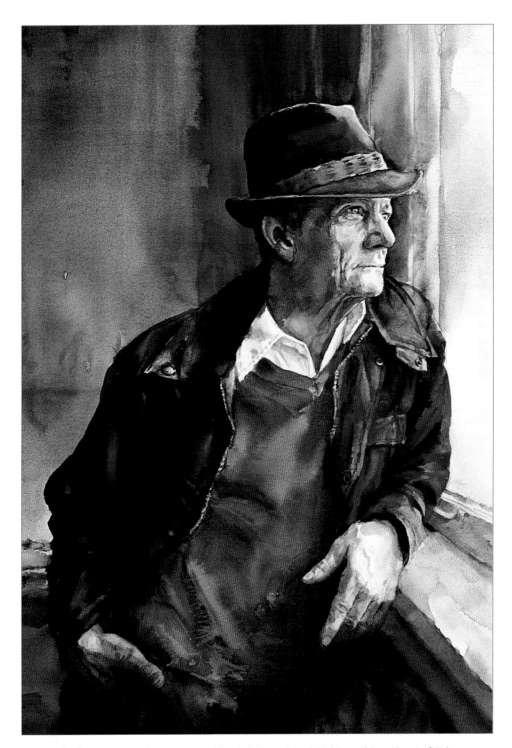

Step 6: Finale To balance out the composition, I darken the background area behind the man's hat with a mix of viridian green, cerulean blue, and sepia. Once it dries, I add more facial color with a mix of permanent rose and raw sienna. I carefully add a touch of French ultramarine blue in the shadows as needed. I add a little shadow to the window ledge using a cerulean blue and sepia mix. Below the ledge, I use French ultramarine blue and sepia. I add a shadow on the right side of his sweater with a watery mix of scarlet pyrrol, permanent rose, cadmium red, and sepia.

EXPRESSIVE LIGHTING

Different combinations and positions of light can lead to interesting surprises. In this painting, the challenge will be to recognize and capture the warm and cool temperatures created by the contrasting lighting.

Palette

French ultramarine blue, manganese blue, quinacridone rose, quinacridone violet, raw sienna, scarlet pyrrol, sepia, titanium white, and viridian green

◄ Lights above and behind the model create a strong backlight with warm highlights and cool shadows. A window to the right provides additional light with cool highlights and warm shadows.

▶ **Step 1: Sketch** By making several changes to the photo, I create a stronger composition. I flip the photo, crop it to a horizontal format, and take out the busy background. I draw the 16" × 12" image on watercolor paper.

▶ **Step 2: Skin tones** Using my large 2" brush, I add a watery mixture of raw sienna, quinacridone rose, and a touch of burnt sienna. I add more pigment to her chin, where the light is strongest.

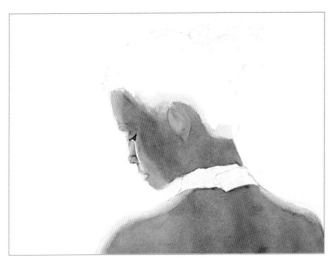

◀ **Step 3: Shadows** Switching between my 2" flat brush and my medium round brush, I wet the entire shadow area of her skin and quickly drop in French ultramarine blue, quinacridone violet, quinacridone rose, and raw sienna. I let the colors mingle and dry.

▶ **Step 4 : Background** I add liquid frisket to her hair before starting the background, which will take several layers. To create a misty look, I drop in titanium white while the paper is wet. I add quinacridone violet, sepia, French ultramarine blue, and manganese blue. I mix sepia and French ultramarine blue for the darkest area of her hair.

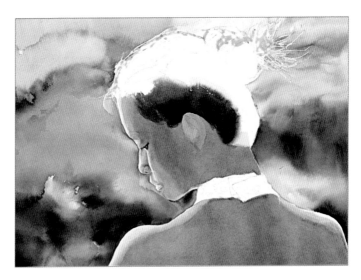

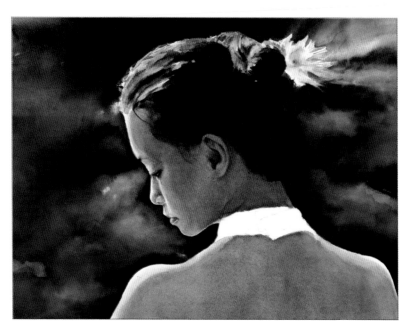

◀ **Step 5: Background and Hair** Using a large round brush, I continue to darken the background. I add more sepia, manganese blue, and French ultramarine blue. I add a layer of titanium white and swirl it around with the tip of the brush. I remove the frisket and paint the warm highlights of her hair with scarlet pyrrol, raw sienna, manganese blue, and quinacridone violet, softening the edges. I finish the cooler, darker areas of her hair with sepia and French ultramarine blue and blend the outside edge into the background.

To soften skin tones, mix titanium white with your established skin colors and lightly brush over the area. Use a 50/50 ratio of water to pigment. Too much water and too much brushing will dissolve and disrupt the existing paint underneath. In this project, I use a mixture of titanium white, permanent rose, and raw sienna. While still wet, I add a mixture of titanium white and viridian green to some of the darker areas.

Facial Detail I paint her eye with several simple strokes of sepia and French ultramarine blue using my small round brush. I add scarlet pyrrol to her nostrils and scarlet pyrrol and quinacridone violet to her lips. I paint her eyebrow with one stroke using a very watery sepia. I drop in more sepia on her brow in the darkest area. I paint her ear with a mixture of quinacridone violet, sepia, quinacridone rose, and raw sienna.

Hair Detail I use an extra small round brush to paint the wispy, backlit hairs. I load the brush with titanium white and mix it with raw sienna or manganese blue. For the wispy hairs around her face, I use a watery mixture of sepia and French ultramarine blue.

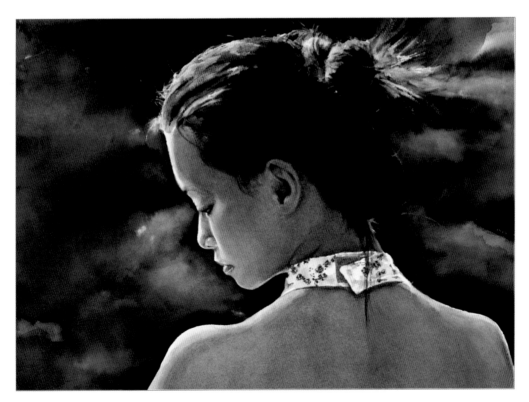

Step 6: Finale Using quinacridone violet, scarlet pyrrol, and quinacridone rose, I paint her satin collar by wetting each shape and lightly dropping in the color. I add a shadow underneath with a watery mixture of French ultramarine blue and quinacridone violet. Once dry, I add a wisp of hair over the collar using sepia and an extra small round brush.

KEEPING IT SIMPLE

Young adults are often very relaxed in dress and attitude, so their portraits should reflect their style. My subject is a young man with a straightforward gaze and casual pose, so I will work in a loose fashion using large areas of color and a simple palette: orange and its complement, blue.

Palette

Burnt sienna, cerulean blue, French ultramarine blue, permanent rose, phthalo blue, quinacridone violet, raw sienna, scarlet pyrrol, sepia, and titanium white

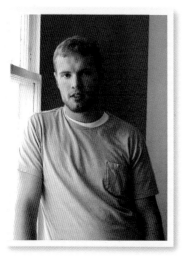

◀ The window will be darker and less detailed in the painting so the figure remains the focal point.

Step 1: Sketch I place the subject slightly off center to create a stronger composition and draw the image 14" × 20".

◀ **Step 2: First Washes** With a 2" flat brush, I lay in a light mixture of raw sienna and permanent rose over his face and up into his hair, as well as on his arms.

Adding the facial features
immediately after adding the
shadows helps you see whether
the shadow values are correct.

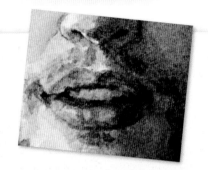

Step 3: Shadows The shadows have a warm purple hue in the photo, so I add a wash of French ultramarine blue and quinacridone violet to the shadow areas of his face and arms. I drop in a little scarlet pyrrol to warm his cheek.

Mouth Detail The corners of his mouth are dark, so I use quinacridone violet and French ultramarine blue. On the lips, I wet each area and lightly drop in permanent rose. I darken the edges with quinacridone violet and add scarlet pyrrol to the center of his lower lip.

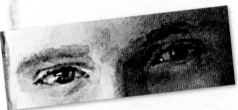

Eye Detail I wet the iris of the left eye and drop in burnt sienna then raw sienna using a small round brush. I use a concentrated mix of sepia and French ultramarine blue to paint the edge of the iris and the eyelashes. For the right eye, I use the same colors but darker values and less detail. I wet the eyebrows and individually drop in raw sienna, burnt sienna, and sepia. I use more sepia on the right. I add a watery mixture of permanent rose and burnt sienna to the shadow on both lids and under his right eye.

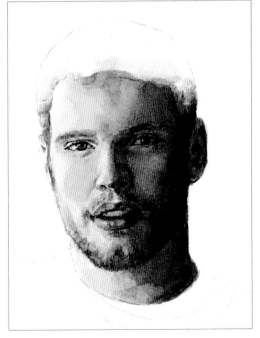

◄ **Step 4: Facial Features** I switch to a medium round brush and add a watery mix of permanent rose and burnt sienna along the right side of his nose and under the nostril. I wet each nostril and drop in the same mixture, then darken with a touch of sepia. I paint each ear with a mix of permanent rose, quinacridone violet, and burnt sienna. I darken areas with French ultramarine blue and a little sepia. I paint the facial hair with a soft, irregular edge using burnt sienna, sepia, and phthalo blue. I wet small areas and drop in color. I paint a few individual hairs with an almost-dry, extra small round brush.

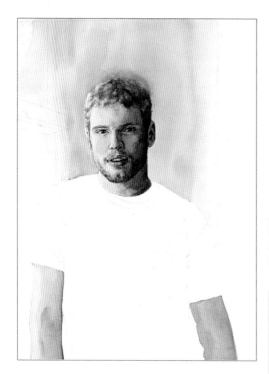

Alternating between painting the background and the figure keeps the figure from having a "cut and pasted" look. The edges are softer and more integrated.

◀ **Step 5: Hair** I use a large round brush to paint the short hair. I wet the lightest area and drop in a watery sepia, and burnt sienna. I add more sepia to the shadow area and a little phthalo blue where I see cooler shadows.

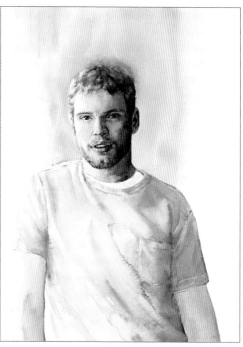

Shirt Detail I continue adding layers to the shirt to define the folds, pocket, and seams. I darken areas with French ultramarine blue and sepia. I finish with an all-over light wash of sepia to neutralize the bright blue.

Step 6: Clothing & Background I paint the shirt in several layers. I start by placing my painting upright. I use a 2" flat brush and apply a loose wash of phthalo blue, quinacridone violet, and a little sepia. I make downward, curvy strokes, and I suggest a pocket by painting around it. I mix an orange background color by using equal portions of scarlet pyrrol and raw sienna, plus a little sepia to neutralize the bright color. I apply the mix to the area behind the figure.

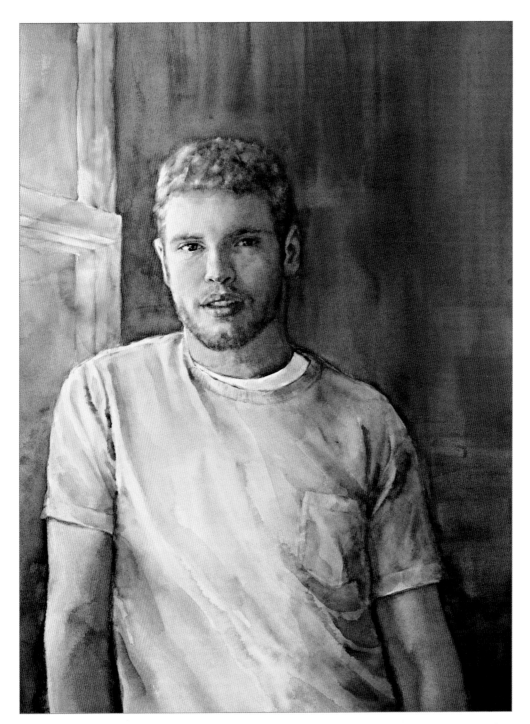

Step 7: Finale Still painting upright, I darken my background color with sepia and add vertical strokes. I add a little phthalo blue and sepia to the right side and let it mix with the orange in both vertical and horizontal strokes. I add washes of phthalo blue, raw sienna, and the orange mixture to the windows. I gradually add quinacridone violet, French ultramarine blue, and sepia to darken the lower window. I soften the facial shadows by adding watery titanium white mixed with raw sienna. I take care not to disrupt the paint underneath. Lastly, I use a damp medium round brush to soften some of the edges of his hair and beard.

CREATING A STORY

Using costumes and adding a scenic background can change an ordinary pose into a captivating story.

Palette

Burnt sienna, French ultramarine blue, quinacridone rose, quinacridone violet, raw sienna, scarlet pyrrol, sepia, titanium white, and viridian green

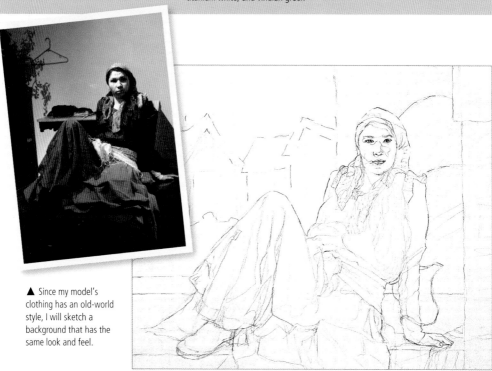

▲ Since my model's clothing has an old-world style, I will sketch a background that has the same look and feel.

Step 1: Sketch Using sketch three (below) as a guide, I draw my 22" × 16" image on the watercolor paper.

Tip

*Small pencil sketches are helpful in working out a design idea.
I like the composition and flow of the third sketch best.*

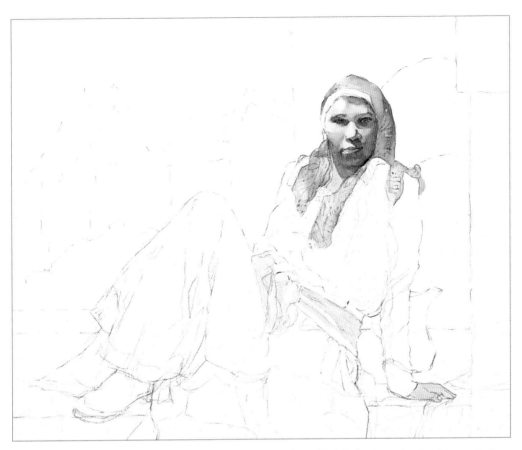

Step 2: First Washes I start by adding liquid frisket to the scarf and the fringe of the belt where I want the white of the paper to show through in the finished painting. I will work upright for this entire project. I use my large round brush and lay in a light mixture of raw sienna and permanent rose over her face and hand. Once dry, I paint a wash of raw sienna over her scarf and drop in burnt sienna, quinacridone rose, and scarlet pyrrol. I wet the shadow area of her face and drop in a quinacridone rose and raw sienna mixture, as well as scarlet pyrrol, viridian green, and French ultramarine blue. I add a very light wash of raw sienna and sepia to the belt.

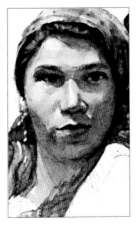

◄ Step 3: Facial Features Before painting her facial features, I add one more layer of viridian green over the shadow area of her face. I paint her irises and eyelashes with sepia using a small round brush. I wet the eyebrow area and drop in sepia. I paint her nostrils with a watery sepia and quinacridone rose and her lips with a mixture of quinacridone rose and a small amount of sepia. I add quinacridone violet to the darker areas.

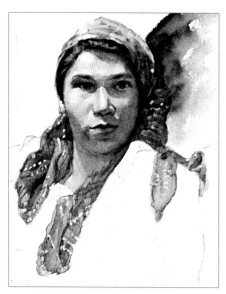

◄ **Step 4: Head Scarf** I paint her scarf by adding raw sienna, scarlet pyrrol, and sepia. I let the colors mix on the paper and add more sepia to the darker areas. I drop viridian green into the folds and shadows. I add several layers of color. I paint the hair above her forehead with burnt sienna and viridian green, adding sepia and French ultramarine blue to the darkest areas. I paint the area behind her head with sepia using loose brushstrokes. Then I remove the frisket from her scarf.

After removing frisket, you can soften the harsh white shapes by adding a few washes of color over some areas. I also used my damp round scrubber brush to soften the edges.

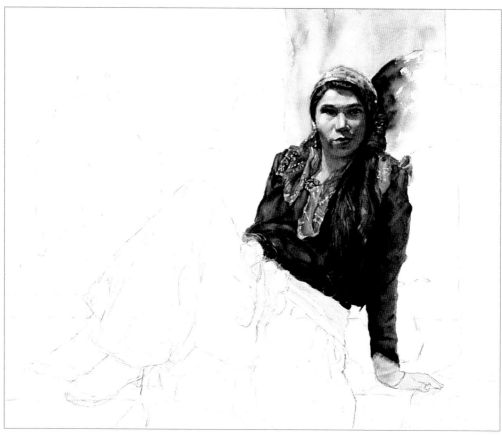

Step 5: Blouse I paint her blouse with a light wash of quinacridone violet mixed with a little sepia. After it dries, I add frisket to the pattern on her collar. I add more washes of quinacridone violet and sepia. For the folds, shadows, and decorative cuff of the sleeve, I add a more concentrated mixture with extra sepia and French ultramarine blue. I remove the frisket and touch up the color with quinacridone violet. I paint the lighter part of the sleeve underneath with a light wash of raw sienna and sepia.

◄ Step 6: Hair

I paint her long hair by wetting the area with my medium round brush and dropping in burnt sienna, quinacridone violet, viridian green, and raw sienna. My brushstrokes follow the pattern of her hair. I add a little scarlet pyrrol to the highlights and a mix of sepia and French ultramarine blue to the darkest areas.

Beginning painters often paint hair using only one or two colors, but, if you observe hair closely, you will see a multitude of colors, including blues, reds, greens, and yellows.

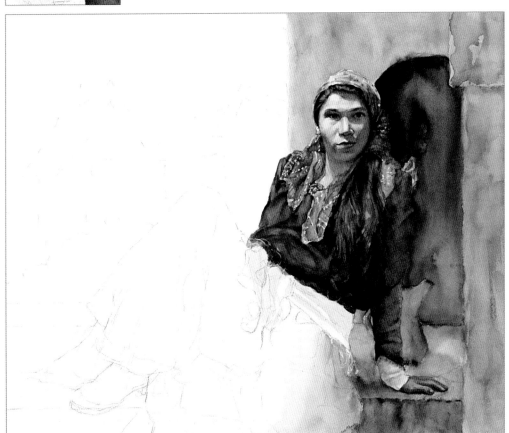

Step 7: Background, Part 1 I paint some of the background before finishing the clothing to better integrate the two. On the right, I lay in a light wash of sepia then add viridian green, raw sienna, and burnt sienna. I do this several times, letting each layer dry. I darken the arch with sepia and the area directly below her hand with washes of sepia and viridian green. As I paint the background, I define the shape of the pitcher by painting around it. I let the paint run off the page. I define her hand by adding a wash of quinacridone rose and raw sienna to the shadow area. While wet, I drop viridian green into the shadows.

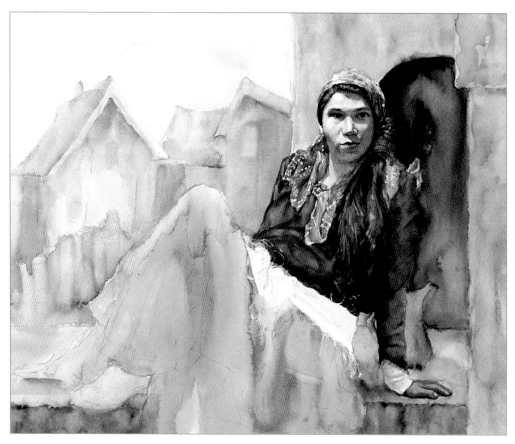

Step 8: Background, Part 2 I wet the sky with a 2" flat brush and add a very light mixture of French ultramarine blue and quinacridone violet. After it dries, I continue with the 2" flat brush and paint the shapes of the buildings and fence with very light washes of viridian green, sepia, quinacridone violet, and burnt sienna. I add more washes to darken the area on the bottom left. I add a mixture of raw sienna, scarlet pyrrol, and sepia to her skirt.

▶ **Step 9: Skirt**
With a large round brush, I paint her skirt using my mixtures of raw sienna, quinacridone rose, and sepia that I used for the scarf. I add viridian green and sepia in the folds and shadows. I paint several layers and build color in a loose manner. I blend some of the edges into the background. I paint her shoe with sepia and French ultramarine blue and add a touch of burnt sienna. I remove the frisket from the belt.

Belt Detail Using my medium round brush, I add washes of burnt sienna and sepia to the folds. I drop in a little viridian green to the shadows. I create the pattern by wetting each shape and dropping in a light mixture of sepia and burnt sienna with a small round brush. I soften the fringe by painting over some of the white areas, previously covered by frisket, with the skirt and blouse colors.

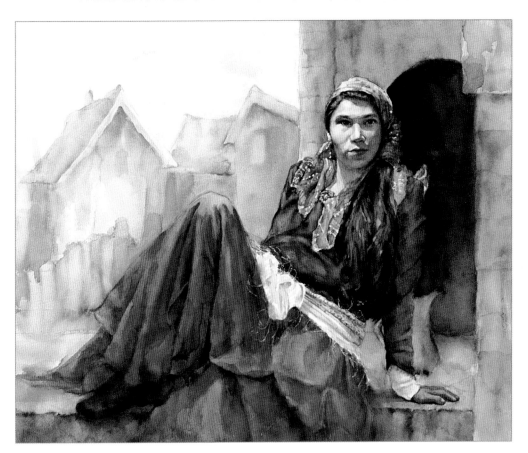

Step 10: Finale I darken the arch behind the woman using a large round brush. I wet the area and drop in sepia and burnt sienna. I soften the contrast of her shoe by adding burnt sienna and blending it into the shoe, skirt, and background. I add texture to the building behind her by painting thin lines of water with a medium round brush and dropping in sepia or burnt sienna. Lastly, I use titanium white and my smallest round brush to add two tiny highlights to her eyes.

FINAL THOUGHTS

Teaching students of all abilities has been a very rewarding experience for me. It's exciting to see a beginning painter suddenly master a technique in class or to see a more advanced painter take a concept and apply it using his or her own unique style and approach.

As with the students in my classes, I am hopeful that this book will help beginning artists learn enough tips and tricks to get started and, as they practice, gain confidence to continue growing in their art. I anticipate that more advanced students will discover ideas or concepts in this book that are new to them and build on their already developing style and ability.

I hope that all readers, beginning and experienced, will continue to discover the joy and excitement that watercolor brings with each new challenge and accomplishment.

—Peggi Habets

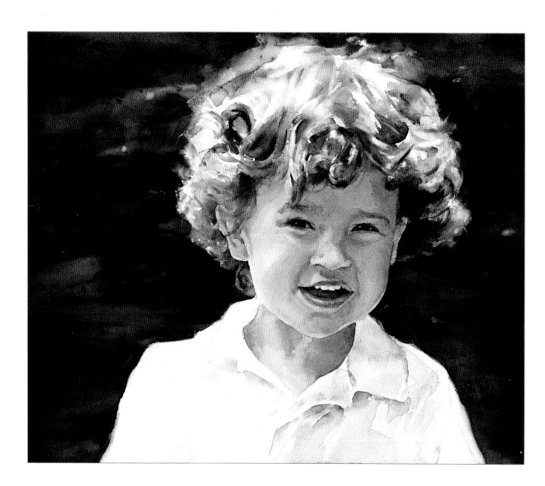